PAST & PRESENT

LUBBOCK

OPPOSITE: Taken in the late 1970s on Broadway Street facing east, this photograph shows pedestrians, vehicles, and businesses in downtown Lubbock. Lubbock witnessed a decline in the city core as numerous businesses moved to new locations. (Courtesy of the Southwest Collection, Texas Tech University.)

LUBBOCK

Daniel Urbina Sánchez and Jazsmine Rénee Sánchez

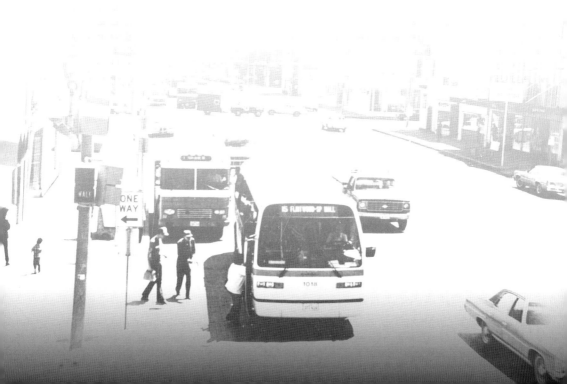

To my parents, Sinforoso G. Sánchez (deceased) and Guadalupe U. Sánchez, whose guidance and patience prepared me to find myself. Thanks to my family for being there and believing that no dream is too big.

—Daniel Urbina Sánchez

To my mom and dad, thank you for all your love and support, regardless of what path I take. Thanks to all the family and friends who have been by my side through it all.

—Jazsmine Rénee Sánchez

Library of Congress Control Number: 2022936221

Published by Arcadia Publishing
Charleston, South Carolina

Printed in the United States of America

For all general information, please contact Arcadia Publishing:
Telephone 843-853-2070
Fax 843-853-0044
E-mail sales@arcadiapublishing.com
For customer service and orders:
Toll-Free 1-888-313-2665

Visit us on the Internet at www.arcadiapublishing.com

ON THE FRONT COVER: Built in 1928, the Fort Worth & Denver Railroad Depot created additional transportation and shipping options for Lubbock. The Buddy Holly Center is now located in the Spanish-influenced building. The area around the center is called the Depot Entertainment District. (Past image courtesy of the Southwest Collection, Texas Tech University; present image by Jazsmine Rénee Sánchez.)

ON THE BACK COVER: Modeled after the Universidad de Alcalá de Henares, the administration building is one of the original structures on the Texas Tech University campus. This picture, taken in 1923, shows the stark and unpaved campus surrounding the newly constructed building. (Courtesy of the Southwest Collection, Texas Tech University.)

CONTENTS

ACKNOWLEDGMENTS

We, the authors of this book, would like to give our thanks to the Texas Tech University Southwest Collection/Special Collections Library for affording us access to their rich treasure trove of historic images. Unless otherwise noted, all the past images came from their holdings. We extend a special thanks to Weston Marshall, reference unit manager, and his dedicated staff. They were instrumental in fulfilling our reference requests and photograph duplications in a timely manner. Similarly, the encouragement and guidance provided by associate dean of libraries Jennifer Spurrier and director Tai Kreidler during the initial phases was heartwarming.

We also wish to thank all the wonderful people who have donated material to the Texas Tech University Southwest Collection/Special Collections Library. Without your generosity, the archives would have scant material for researchers to view. Having the luxury of looking through thousands of images helped us define the look of our book.

We would also like to thank all those scholars whose works are invaluable when compiling Lubbock's history: Katie Parks for Remember When, a wonderful collection of the rich history of Lubbock's African American community; Dr. Paul H. Carlson for his work *The Centennial History of Lubbock: Hub City of the Plains*; and the Texas State Historical Association for its online Handbook of Texas.

Additionally, I, Daniel, would like to thank my coauthor, Jazsmine Rénee Sánchez, for her wonderful work in capturing all the present images in this book. Her craft and attention to detail are stellar. Her determination to find just the right vista allowed us to find the shot. Her unique combination of visual, artistic, analytic, and verbal skills made her the perfect coauthor.

INTRODUCTION

Lubbock, Texas, was the result of a compromise between two competing hamlets that decided to join forces and create a stronger union. However, the story of humankind in this area goes back 12 millennia, when the first humans walked across these plains before the Spanish named the larger plains the Llano Estacado.

While we selected images showcasing Lubbock's pictorial history, we would be remiss if we did not mention a truncated timeline of humans in this area. The archaeological record has documented human presence from the Paleoindian, Archaic, Ceramic, Protohistoric, and Historic Periods. The history of the land before the existence of Lubbock is vast, and others, including Dr. Paul H. Carlson (in his book *The Centennial History of Lubbock: Hub City of the Plains*), have covered it in detail.

A brief overview of the timeline includes the Paleoindian Period (11,500 to 8,500 years ago). Game animals from this period are now extinct. The next several thousand years saw a switch from animals to plants as a source of food; this was during the Archaic Period (8,500–2,000 years ago.) The Ceramic Period came next, from 2,000 years ago to AD 1450. This period was categorized by pottery and arrows made and used by humans. The Protohistoric Period followed, from AD 1450 to 1650. During this time, the indigenous groups and the Europeans shared space. The Historic Period, from 1650 and forward, is next. During this period, Anglo-Europeans began to impact the region.

The first of the Europeans to impact the plains were the Spaniards. Their initial forays came in 1541 as they searched the area for Quivira, a land of unfathomable riches. Francisco Vasquez de Coronado led an expedition of men and women across the region. Evidence suggests some part of the army passed through the area now called Mackenzie Park and the Lubbock Lake. The group also painstakingly mapped the area and recorded its flora and fauna. All the major features of this region, which they named the Llano Estacado, were named or renamed. Many streams, landmarks, and landforms in this area still carry these given Spanish names. Water resources at the Yellowhouse Draw, Blackwater Draw, and La Punta de Agua were used by the Spanish, Comancheros, Ciboleros, and others for hundreds of years. Then Anglo-European groups started coming to the Llano Estacado. When Albert Pike traveled through the area that would become Lubbock, it was still part of Mexico. That changed with the success of the Texas Revolution in 1836, after which the site became part of the Republic of Texas. In 1845, Texas joined the United States. After the war with Mexico (1846–1848), the region was still a part of the United States.

Soon, these new owners started encroaching into Comancheria—the vast territory of the Comanche. Other battles came, but by 1874, the region was primed for settlement. In 1876, the Texas Legislature created Lubbock County. This prompted speculators, land developers, real estate agents, and others to relocate to the region. Some of the newcomers formed rival communities and eventually agreed to move to a new location. After the two groups literally moved homes and buildings to the new location, they began the process of making a city. The early city leaders began building businesses, churches, and schools and worked on securing railways. By the time

Lubbock was formally incorporated in 1909, the city had a significant infrastructure. A ceremonial passenger train arrived in late October 1909 to celebrate the new railway, and a second rail line would soon be in the city. Lubbock was already becoming the hub of the plains. Schools, hospitals, and a college would spur the city forward.

Lubbock is now home to major medical facilities, premier universities, agriculture, a transportation hub, a growing arts and entertainment district, and over 249,000 people. As the city has grown, the population has shifted toward the south and southwest. The South Plains Mall was established at South Loop 289 and Slide Road. The areas south of the loop between Highway 87 and Frankford began to attract businesses and homeowners. Then, the areas past Eighty-Second Street followed a similar path. After this, pockets of development headed toward Wolfforth, Texas, on the west-southwestern edge of Lubbock.

Part of the city's growth was spurred by the May 11, 1970, tornado that destroyed much of Lubbock's original city core, the Guadalupe neighborhood, and the Lubbock Country Club area. The storm was later categorized as an F5 tornado. As part of the rebuilding efforts, residents of the devastated area were placed in homes in the new Cherry Point addition. The homes were part of Lubbock's efforts to attract residents to the new Estacado High School. Estacado High was designed to be a truly integrated school; however, white flight had begun, and homes were available for the mostly displaced Mexican American residents.

One of Lubbock's main travel routes is the Marsha Sharp Freeway, formerly known as the Brownfield Highway. The city renamed the freeway to honor Coach Sharp after she led the 1993 Texas Tech Lady Raiders to a national basketball title. Her team, spearheaded by Sheryl Swoopes and Krista Kirkland with a wonderful supporting cast of players, brought Lubbock into the national athletic spotlight. Another result of the successful Lady Raiders and the Red Raiders teams from that era was the construction of the United Spirit Arena, the first major building developed at Texas Tech University in several years. The growth spurt on campus has continued, and today, the campus spreads to its boundaries. Lubbock Christian University has followed a similar growth pattern. It has numerous national titles in women's and men's basketball and a baseball title. The campus has erected multiple new buildings. The student population continues to grow as graduates from the Lubbock Christian School file in. Other local school districts have followed suit. Once, the Lubbock Independent School District was the only game in town. However, due to the city's growth, it now has the Cooper Independent School District, Frenship Independent School District, and various private schools clamoring for and recruiting Lubbock's students.

In addition to the thriving schools and sports programs, Lubbock has seen its share of development and revitalization. At one time in the not-so-distant past, downtown Lubbock was the center of attraction, with shops and eateries catering to the public and fulfilling their needs. As time carried on and the population expanded, small mom-and-pop shops were abandoned and taken over by national retail stores on the outskirts of town; downtown Lubbock appeared to be a ghost image of its former self. Currently, downtown is in the midst of a multiyear redevelopment project. The developers seek to entice people to the downtown area and recapture the sense of a shared space for the community. The project involves upgrading the infrastructure and taking advantage of the growing Arts and Depot Entertainment Districts. The Arts District is highlighted with the First Friday Art Trail. The additions of Buddy Holly Hall and numerous art galleries and performance spaces beckon people downtown. Similarly, the Depot Entertainment District, filled with music venues, restaurants, and bars, draws visitors downtown.

EARLY LUBBOCK

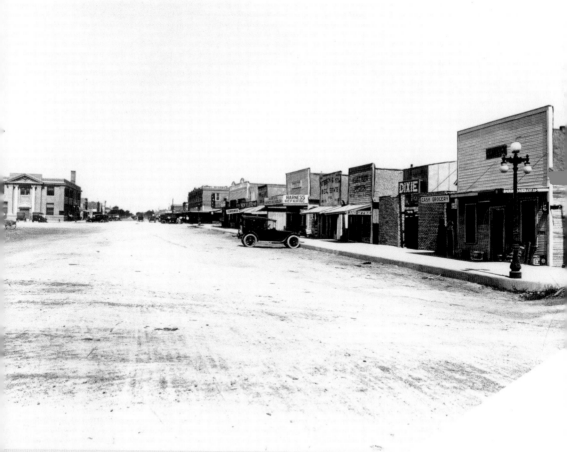

This undated picture of early downtown Lubbock shows the unpaved streets lined by businesses. A bond passed in 1920 allocated the funds to begin paving the streets with red bricks. Today, the red bricks serve as a reminder of the city's legacy. (Courtesy of the Southwest Collection, Texas Tech University.)

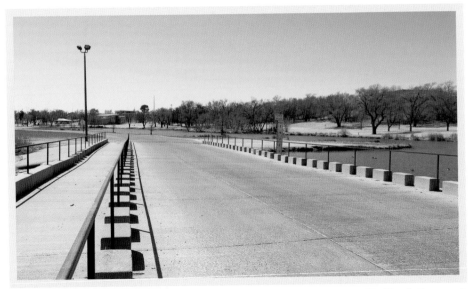

This 2013 image captures a vista along the bank of the Double Mountain Fork of the Brazos River in Mackenzie State Park in Lubbock. A Lubbock historical marker at the site reads, in part: "In the summer of 1878, O.W. Williams and E.M. Powell began a survey of Lubbock County. It began at this point where the two forks of the Brazos River meet." (Below, courtesy of the Southwest Collection, Texas Tech University.)

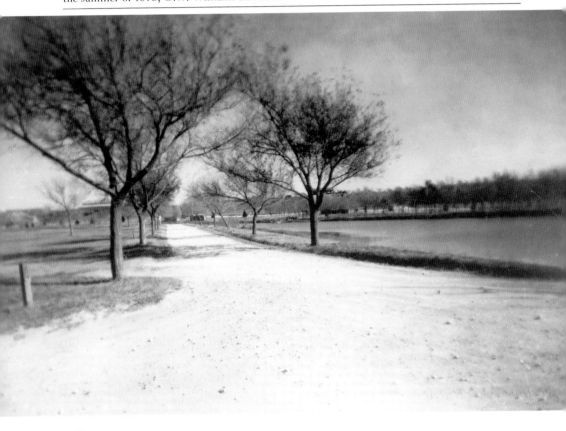

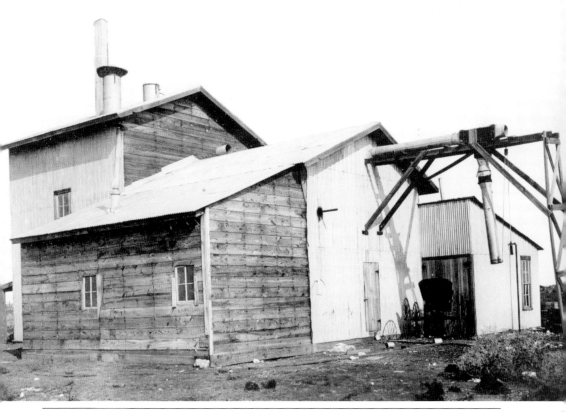

This 1906 image shows the first cotton gin in Lubbock. A historical marker at 1719 Avenue A commemorates the gin, which was created by Frank Wheelock and others. By the 1920s, the Lubbock Cotton Oil Company and Lubbock Compress Company had altered the original site. Today, the Caviel Museum for African American History accompanies the marker site. (Above, courtesy of the Southwest Collection, Texas Tech University.)

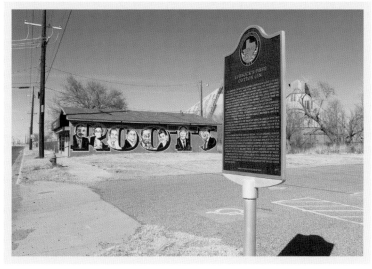

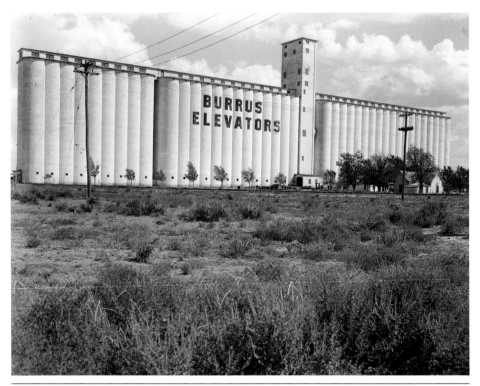

Pictured in the 1940s is the iconic Burrus Mill and Elevator, located just north of Fourth Street on Avenue P. Although the structure survived the tornado that hit Lubbock on May 11, 1970, it was demolished for the Marsha Sharp Freeway project. The freeway is shown in the modern image below; a small piece of the new Buddy Holly Hall is rising over the road. (Above, courtesy of the Southwest Collection, Texas Tech University.)

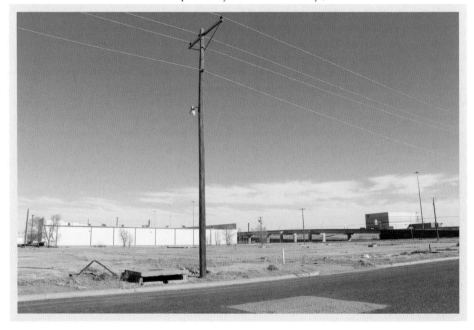

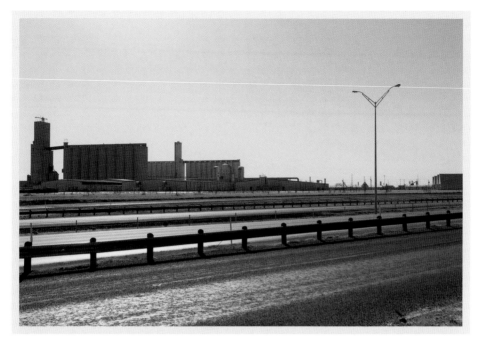

Taken in 1970, the below image displays the destruction left after the May 11 Lubbock tornado. Over the years, the outer loop has been completed along with newly developed neighborhoods. Taken about a block past Interstate 27 and the north frontage road of Loop 289, the present image highlights the development of North Loop 289. (Below, courtesy of the Southwest Collection, Texas Tech University.)

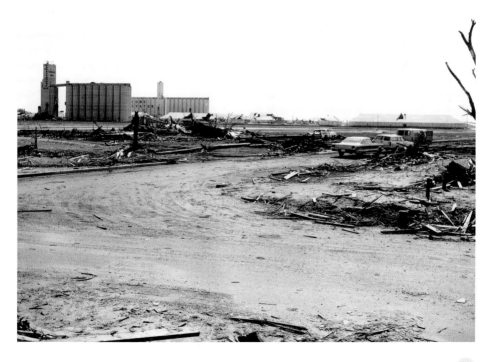

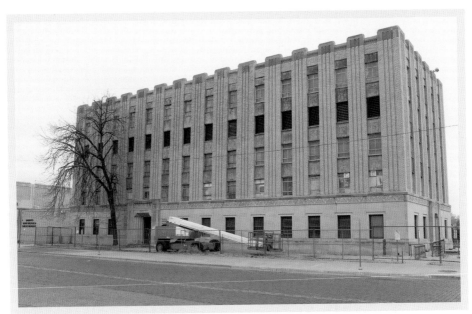

The undated image below is titled "Razing of the Old County Jail." Although it is difficult to know for sure, the men in the image appear to be mostly Mexican American or African American. A three-story building was constructed in the old jail's place in 1931. The new structure, still undergoing renovations, is now the home of the Lubbock County Sheriff's Department. (Below, courtesy of the Southwest Collection, Texas Tech University.)

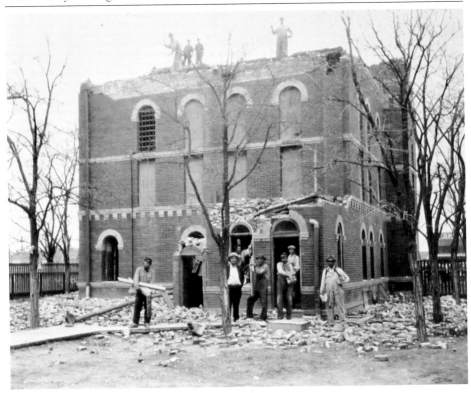

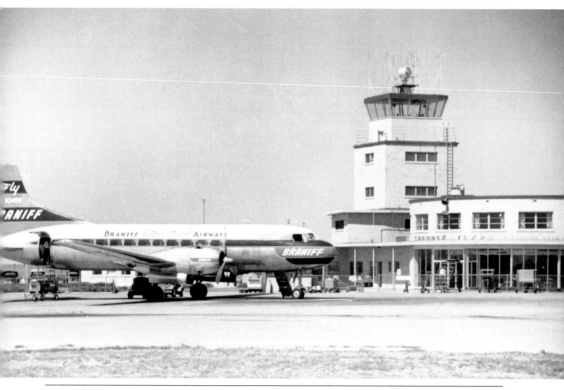

Braniff International Airlines was among the carriers that flew into Lubbock Municipal Airport. The airport terminal moved to a new location, and the old structure is now the Silent Wings Museum, which opened in 2002. The museum preserves and promotes the history of the World War II military glider program. (Above, courtesy of the Southwest Collection, Texas Tech University.)

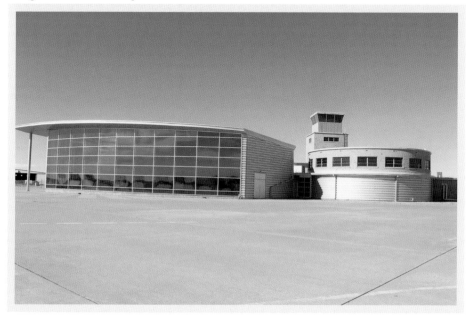

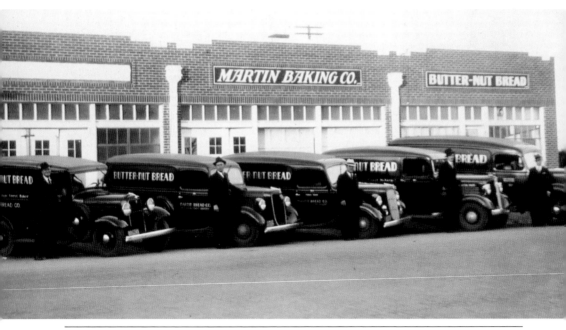

Martin Baking Company, located at the northeast corner of Broadway Street and Avenue E, is shown above in an undated image. A fleet of delivery vehicles is parked in front of the bakery. Today, the building is the Broadway Plaza at 602 Broadway Street, and it houses an attorney and a photography studio. (Above, courtesy of the Southwest Collection, Texas Tech University.)

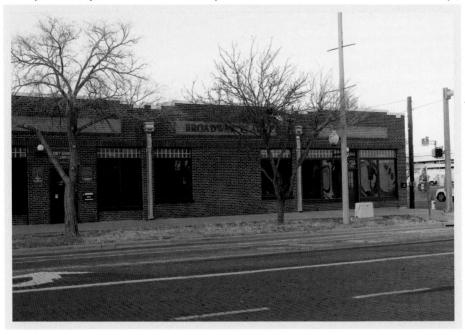

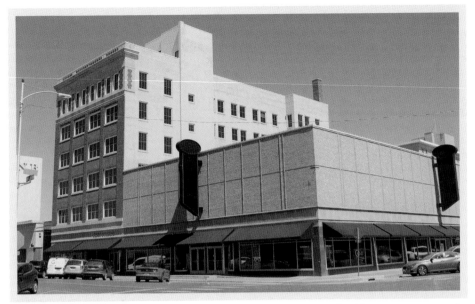

The 1944 photograph below shows the Renaissance Revival Myric-Green Building rising up behind the Dryer and Lee Oil Company. The historic building at 1211 Avenue J still stands; the lower portion is home to local restaurant Italian Garden. A newer building now exists at the garage's location and is available for private and public events. (Below, courtesy of the Southwest Collection, Texas Tech University.)

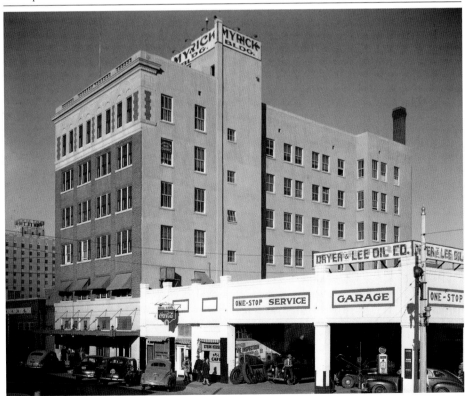

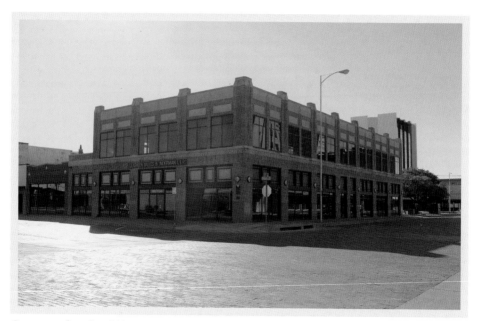

Constructed in the 1930s in an art deco style, this was originally the Cotton Exchange Building. Charles Paul Carlock and Watson Carlock have been continuous tenants since the 1930s, and it was renamed the Carlock Building. It now houses the Glasheen, Valles & Inderman Law Firm. (Below, courtesy of the Southwest Collection, Texas Tech University.)

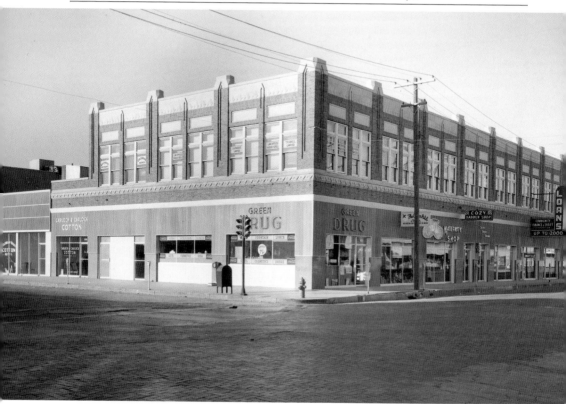

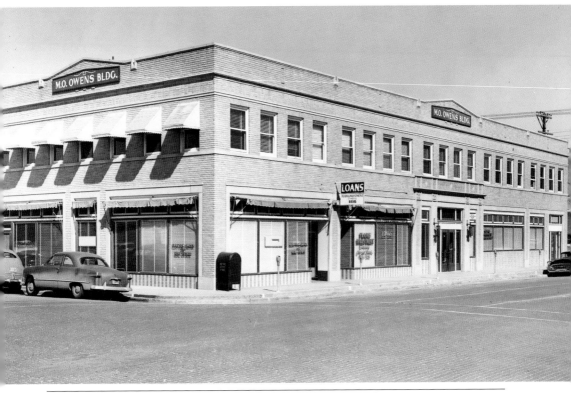

The 1956 image above shows the Ralli House, which was constructed in 1930 and originally named the Owens Building. The brick structure features two stories, terrazzo floors, and wood accents. Local attorney and former city council member Victor Hernandez owned the building for many years. (Above, courtesy of the Southwest Collection, Texas Tech University.)

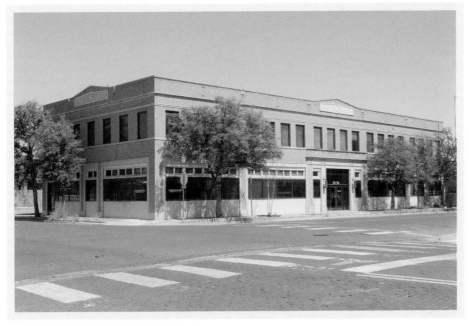

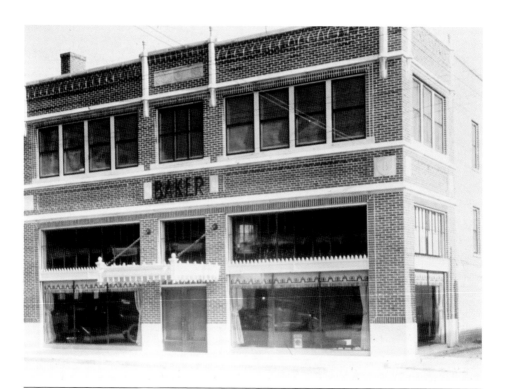

The undated image above shows the Baker Building, one of several Baker listings in the 1935 Lubbock directory. The listing shows 1107–1109 Thirteenth Street as the location for the Baker Furniture Corporation. Baker sold this building to the Watsons. Below is the refurbished and historic Watson Building at 1109 Thirteenth Street. It is available for use as a venue for any event. (Above, courtesy of the Southwest Collection, Texas Tech University.)

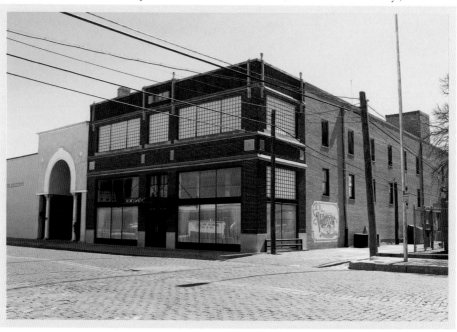

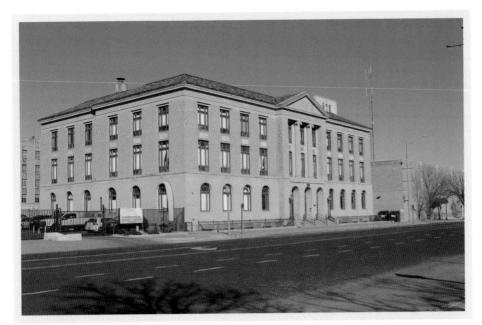

This is the Lubbock Post Office and Federal Building. Built in 1932, the Classical Revival three-story building is still a prominent feature of downtown Lubbock. After several years of abandonment, the damaged structure was repurposed as lofts. The elegantly restored Courthouse Lofts feature 23 unique units. (Below, courtesy of the Southwest Collection, Texas Tech University.)

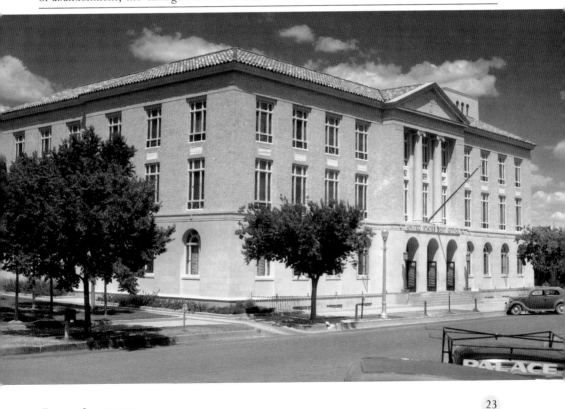

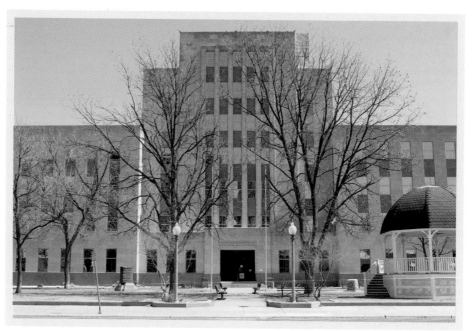

The 1950s image below features the third Lubbock County Courthouse, which was designed by architect Sylvan Blum Haynes. Construction began in 1949 and finished in 1950. The courthouse underwent a major addition in 1968, including a gazebo. This is where the High Noon summer concert series takes place. La Raza on the Plaza is another event held in front of the courthouse. (Below, courtesy of the Southwest Collection, Texas Tech University.)

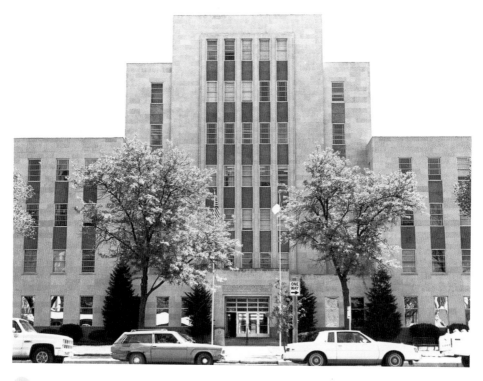

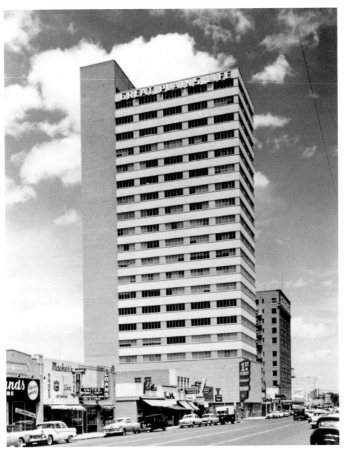

The undated image at left shows the Great Plains Life Building. Designed by architect David S. Castle, the 20-story high-rise is an example of a mid-century office building. Although it sustained damage during the May 11, 1970, tornado, the structure was repaired in the early 1970s. The building still stands; in 2022, it was slated to be the future home of Metro Tower Lofts. (Left, courtesy of the Southwest Collection, Texas Tech University.)

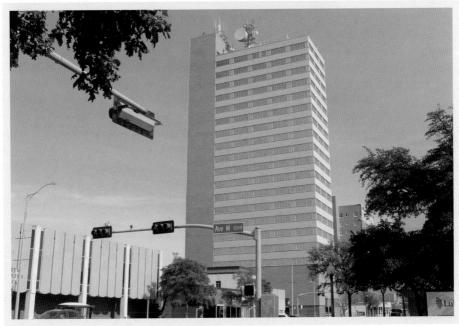

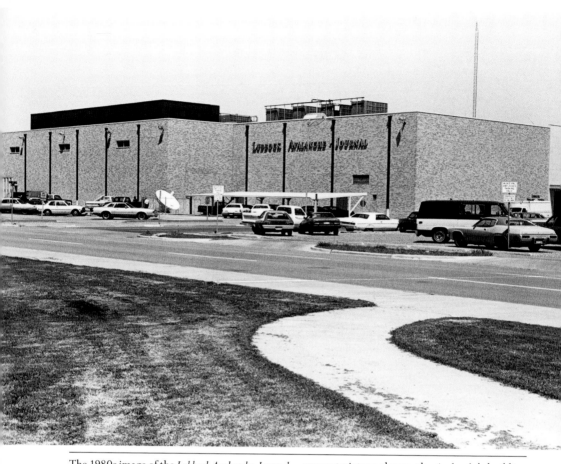

The 1980s image of the *Lubbock Avalanche-Journal* shows a rather large building. Since the rise of the internet, many major newspapers have retooled and restructured their ventures. As the present picture shows, the *Avalanche*'s building has undergone a major and expansive renovation. (Above, courtesy of the Southwest Collection, Texas Tech University.)

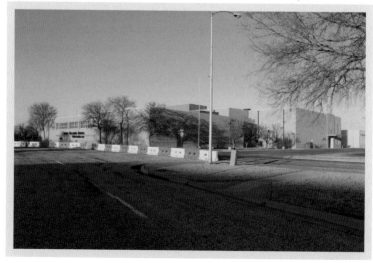

A Time to Read,
Learn, and Reflect

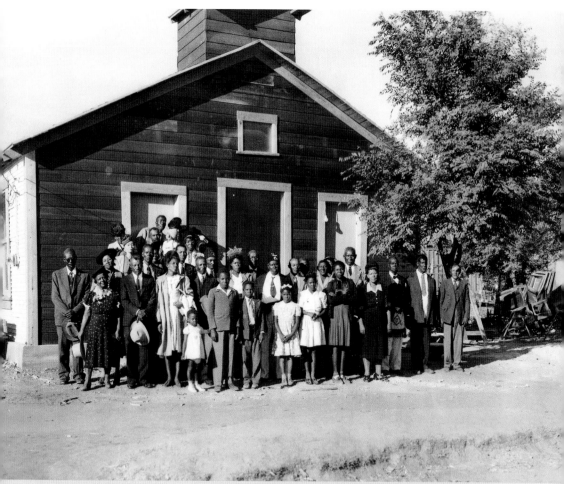

Members of an African American congregation posed in front of their church in the 1940s. Churches and schools were the pillars that allowed African Americans to flourish during the era of segregation. (Courtesy of the Southwest Collection, Texas Tech University.)

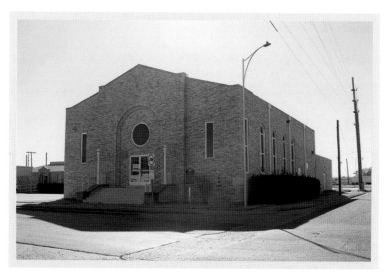

Depicted below is New Hope Missionary Baptist Church in 1949. Located at 2002 Birch Avenue, the church was designated as a significant part of Lubbock and Texas history by the Texas Historical Commission. Since its beginning in 1926, it has continued to be a pillar of the East Lubbock community by hosting various activities and celebrations such as Juneteenth. (Below, courtesy of the Southwest Collection, Texas Tech University.)

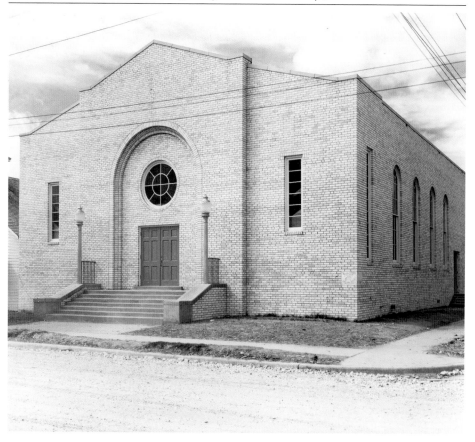

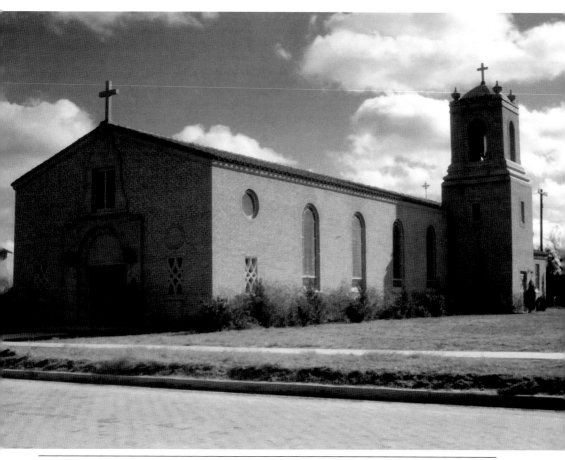

The 1938 image above shows St. Elizabeth's old chapel at 2305 Main Street. The church survived the tornado on May 11, 1970. The church's growing congregation has led to major expansions. The congregation gathers at what is now called St. Elizabeth's University Parish at 2316 Broadway Street, just south of the original chapel. (Above, courtesy of the Southwest Collection, Texas Tech University.)

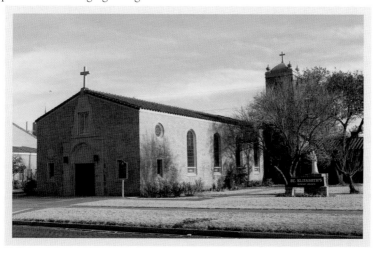

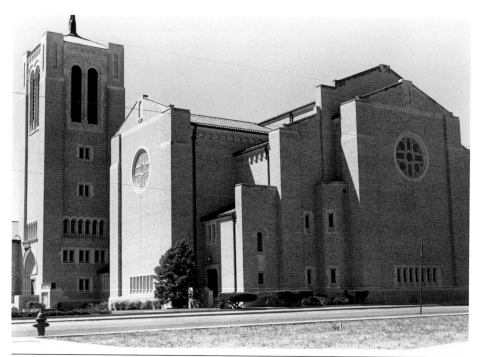

The First Baptist Church at 2201 Broadway Street is shown above in 1980. The congregation traces its roots back to 1891, when members began meeting at the county jail (which they did until 1901). The congregation built a small church at Thirteenth Street and Avenue G. Due to the growth spurred by the opening of Texas Tech, the church had moved to Broadway Street and Avenue V by 1951. (Above, courtesy of the Southwest Collection, Texas Tech University.)

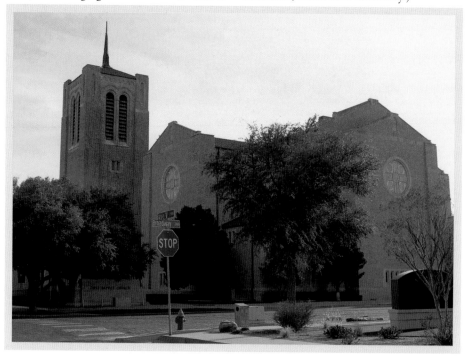

A TIME TO READ, LEARN, AND REFLECT

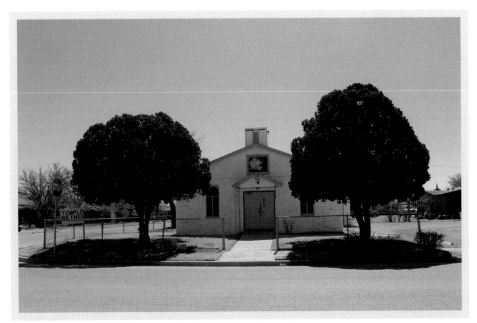

Templo Bethel of the Concilio Latino Americano de Iglesias de Cristianas was located at 223 North Avenue N when the below photograph was taken in 1951. The congregation is pictured in front of their church. The church was organized on January 15, 1943, and the temple was erected on May 21, 1953. (Below, courtesy of the Southwest Collection, Texas Tech University.)

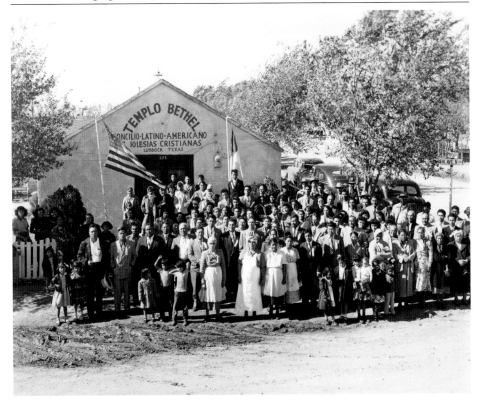

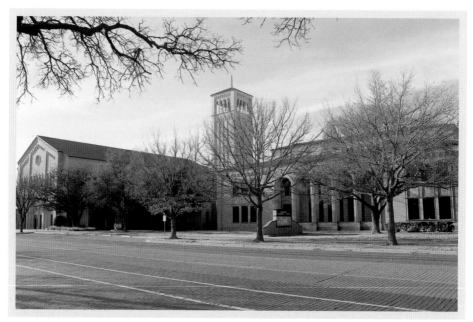

The undated image below shows the Broadway Church of Christ at 1924 Broadway Street. In the 1950s, the church served as a site for kindergarten through college education and was the genesis of Lubbock Christian School and Lubbock Christian University. (Below, courtesy of the Southwest Collection, Texas Tech University.)

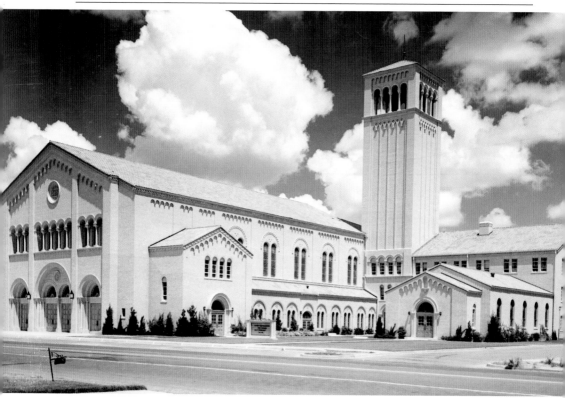

A TIME TO READ, LEARN, AND REFLECT

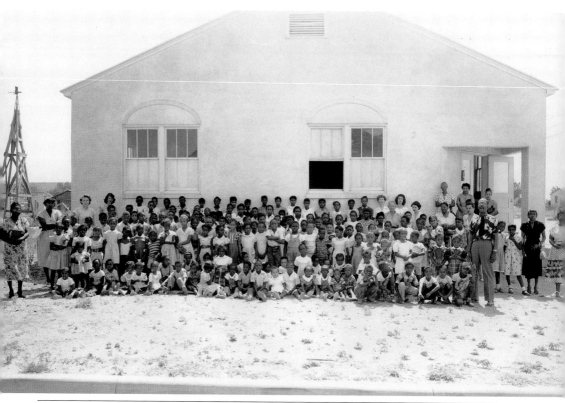

The 1951 image above shows the congregation of Carter Chapel Christian Methodist Episcopal Church in front of the church building. The church was organized in 1920. (Above, courtesy of the Southwest Collection, Texas Tech University.)

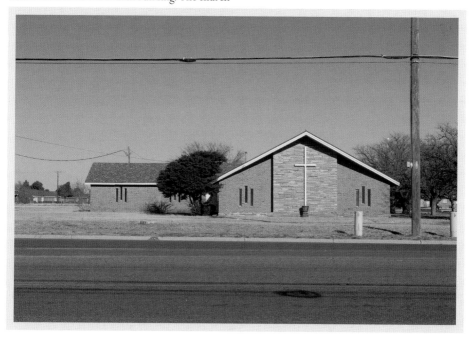

Mission Orange Bottling Company, located at 2003 Baylor Street, is shown in the above image. The company was in operation from 1951 to 1963. While the exterior of the building remains mostly unchanged, the building was repurposed and is now utilized by the Texas Migrant Head Start program. This program provides care and education for children who are not yet old enough to attend school. Migrant workers and the needs of their families remain a reality in 2022. (Above, courtesy of the Southwest Collection, Texas Tech University.)

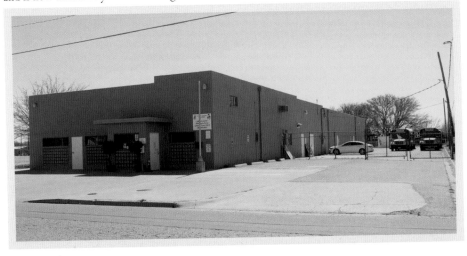

A TIME TO READ, LEARN, AND REFLECT

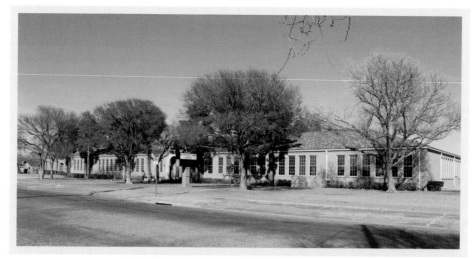

The 1949 image below depicts Bean Elementary School at 3001 Avenue N. George R. Bean, the school's namesake, was a cowboy, teacher, lawyer, and Lubbock County judge. The one-story structure has maintained most of its historic charm. Although many schools in minority neighborhoods have been closed due to consolidation, Bean remains open. (Below, courtesy of the Southwest Collection, Texas Tech University.)

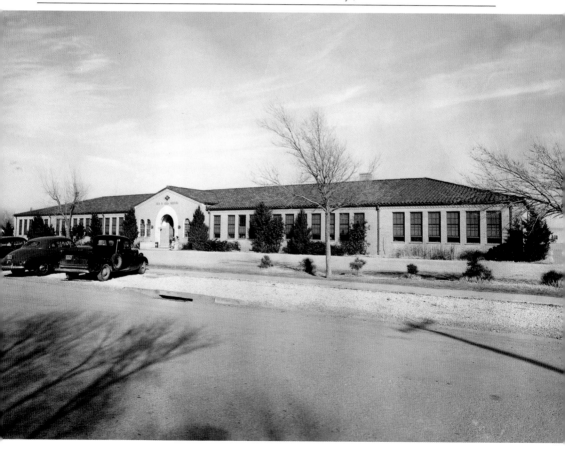

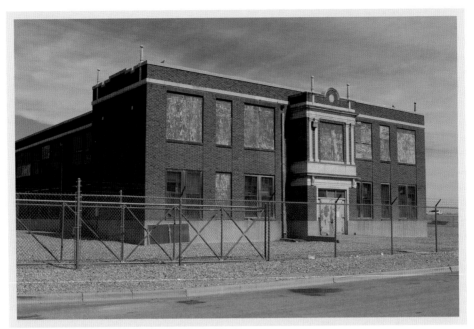

The below image of Liff Sanders Elementary School is from 1927. It was named after Elifet "Liff" Sanders, the first resident minister in Lubbock. The two-story structure was designed to house 525 students. Although prohibitions existed regarding segregated schools, the Lubbock School District continued the practice, and the school had over 90 percent Mexican American enrollment by early 1960s. Eventually, the school was closed. (Below, courtesy of the Southwest Collection, Texas Tech University.)

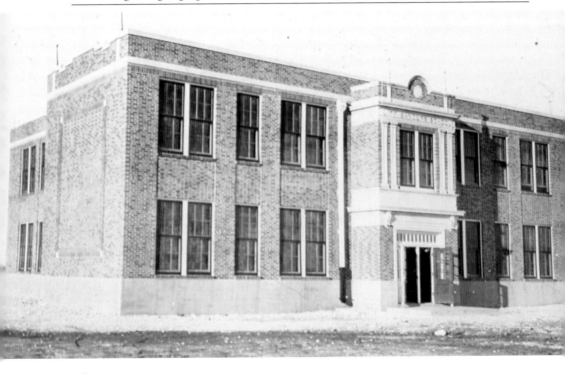

A TIME TO READ, LEARN, AND REFLECT

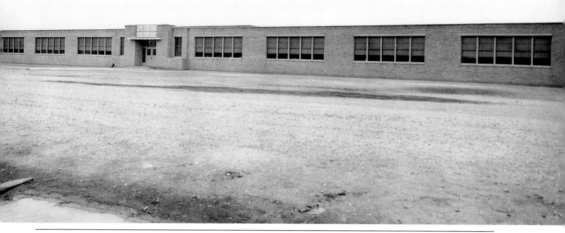

A.C. Jackson Elementary School was built in the 1940s at 201 North Vernon Avenue. The above photograph shows the school in 1951. Additions took place in the late 1980s. Jackson Elementary School was permanently closed for the 2021–2022 school year—a victim of the consolidation of schools in minority neighborhoods in Lubbock. Lifelong educator Anita Carmona Harrison is the namesake for a new North Lubbock elementary school. (Above, courtesy of the Southwest Collection, Texas Tech University.)

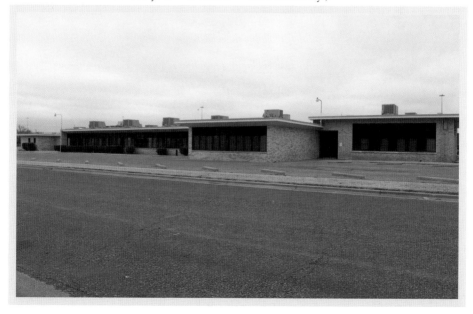

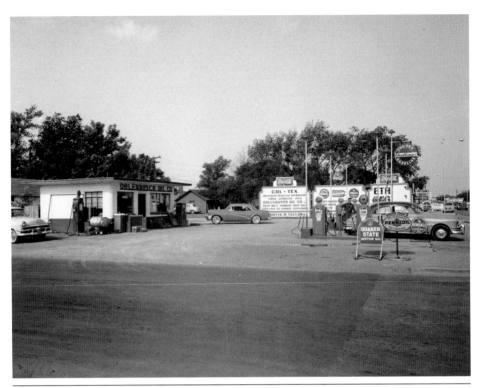

Ohlenbusch Oil Company, located at 216 North College Avenue, featured a full-service gas station. Lauro Cavazos Middle School now stands at the location. It was built in 1993 after parents and other plaintiffs successfully sued the Lubbock Independent School Board. Cavazos Middle is a magnet school and the first to offer mariachi courses. Sadly, the namesake for the school, the first Hispanic US secretary of education, passed away in March 2022, while this book was being written. (Above, courtesy of the Southwest Collection, Texas Tech University.)

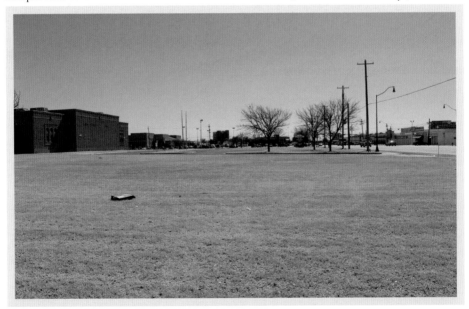

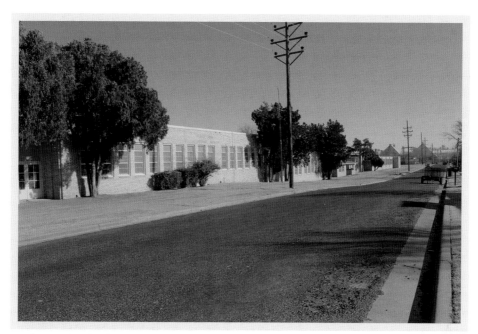

Dunbar High School is shown below in 1950. Located at 2401 Date Avenue, the school is a reminder of the country's legacy of racism and segregation. The students who attended Dunbar created their own destiny, with numerous graduates going on to attend historically black colleges and universities. Athletically, the Dunbar Panthers dominated the Prairie View League. When Estacado High School opened in 1967, many of the Panthers became Matadors and began their own legacy. (Below, courtesy of the Southwest Collection, Texas Tech University.)

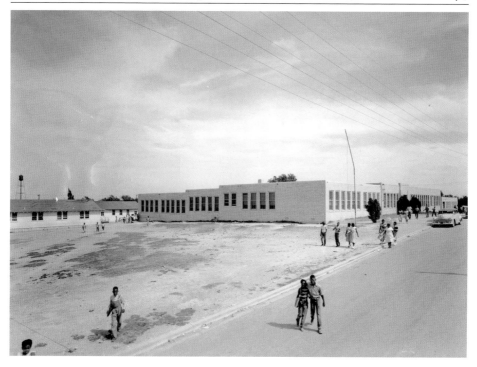

The first Lubbock High School building is shown in the undated image below. The structure was on Thirteenth Street between Avenue P and Avenue O. This building became Carroll Thompson Junior High School after the new Lubbock High School was constructed in 1931. Many still speak of the football rivalry between Lubbock High and the Matthews Broncs. The Pete Ragus Aquatic Center now resides at this location. (Below, courtesy of the Southwest Collection, Texas Tech University.)

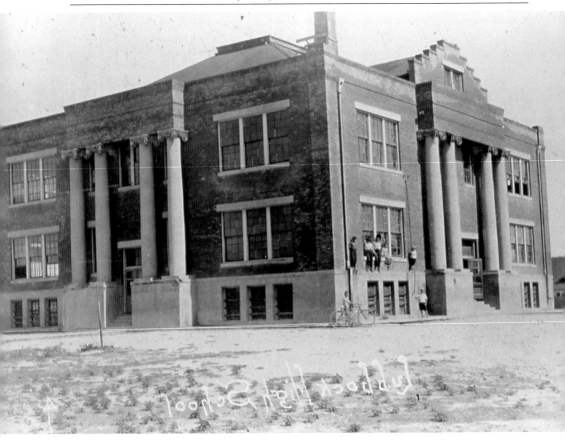

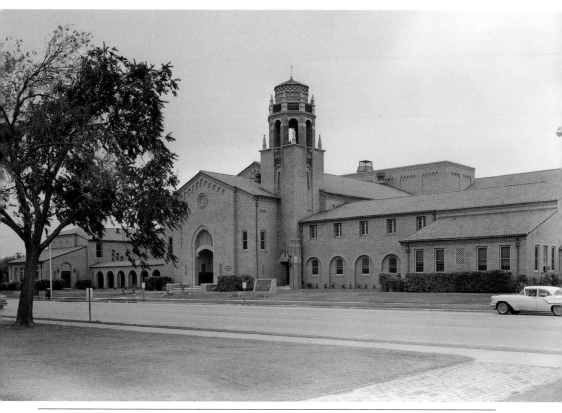

The 1949 image above shows the Lubbock High School building located at 2004 Nineteenth Street. The three-story North Italian Romanesque structure was completed in 1931. The Texas Historical Commission erected a historical marker at the school in 1984. Home to the Westerners, the school has continued making renovations over the years to accommodate its growing student population. Academically, Lubbock High is a magnet school and offers International Baccalaureate programs. (Above, courtesy of the Southwest Collection, Texas Tech University.)

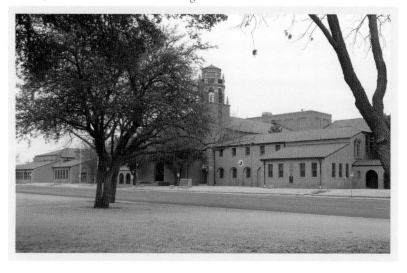

Matthews Junior High School is pictured above in 1953. By the late 1960s, the student body was primarily Mexican American. Now named Matthews Academy, it provides a personalized learning environment for high school students facing struggles in their lives. Students also receive the aid and support they need to ensure their success and readiness for life after graduation. The facility hosted an all-class reunion in October 2021. (Above, courtesy of the Southwest Collection, Texas Tech University.)

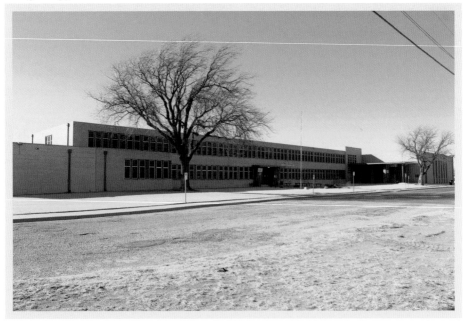

The Speech Building and the Agriculture Pavilion on the campus of Texas Tech University are shown in the undated image below. The Speech Building has since been removed, but the Agriculture Pavilion still stands. The pavilion was repurposed as the design studio for the landscape architecture program. The Southwest Collection/Special Collections Library now surrounds the pavilion. The archive houses an extensive oral history program and collection. (Below, courtesy of the Southwest Collection, Texas Tech University.)

The below photograph of Lubbock Christian College's entrance was taken in 1989. The college opened in 1957 and has grown from a small school to a university. Today, the school offers over 65 academic degrees and has a stellar sports program. While the school has grown immensely, it still affords students a close-knit community. The university holds 17 national championships. Recently, the women's basketball team has won several national titles. (Below, courtesy of the Southwest Collection, Texas Tech University.)

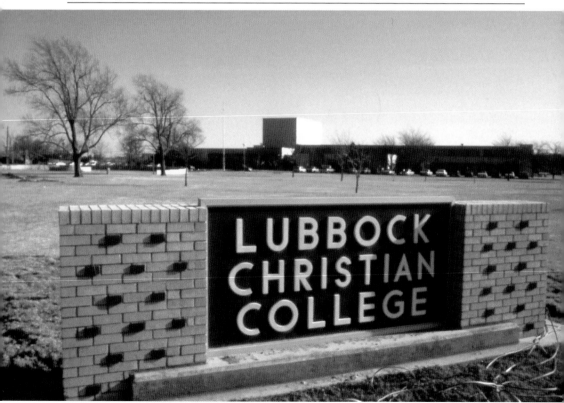

SHOWTIME IN THE HUB

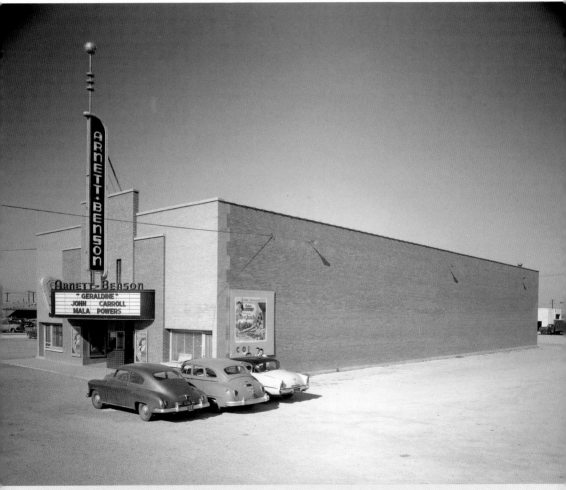

The Arnett Benson Theater was located at 105 North College Avenue. The marquee in this 1954 image promotes *Geraldine*, starring John Carroll and Mala Powers. The theater was one of a chain owned by Lubbock businessman and future governor of Texas Preston E. Smith. (Courtesy of the Southwest Collection, Texas Tech University.)

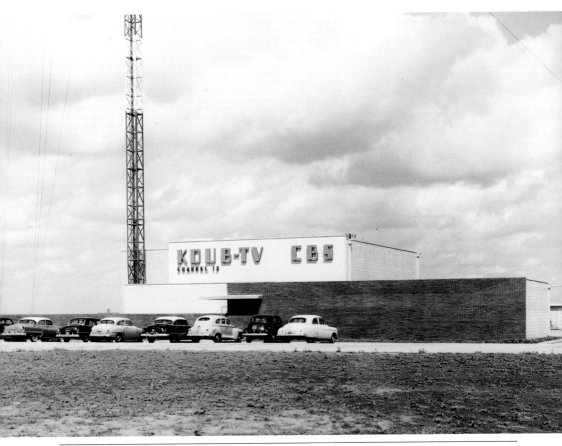

Established in 1952, KDUB-TV 13 was a CBS affiliate and the brainchild of W.B. "Dub" Rogers. The novelty of television during the 1950s allowed for local stations to host live remotes. Located at 7400 University Avenue, the station is now owned by Nexstar Media Group, which owns and operates KLBK 13 and KAMC 28. The stations share news, including Doppler radar updates and severe weather coverage. (Above, courtesy of the Southwest Collection, Texas Tech University.)

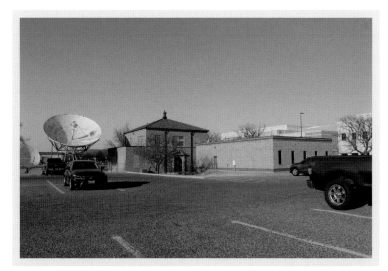

This undated image below features KTXT Public Broadcasting on the campus of Texas Tech University and shows the building prior to renovations and additions. The current image gives few visual cues as to the growth experienced on this section of the campus. Texas Tech Public Media provides the region with public television and radio programming. It operates KTTZ-TV and KTTZ-FM. (Below, courtesy of University Archives, Texas Tech University.)

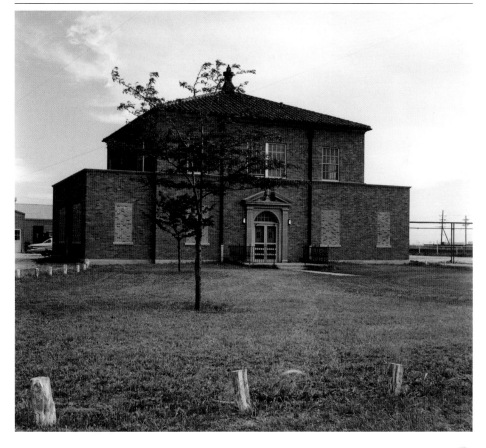

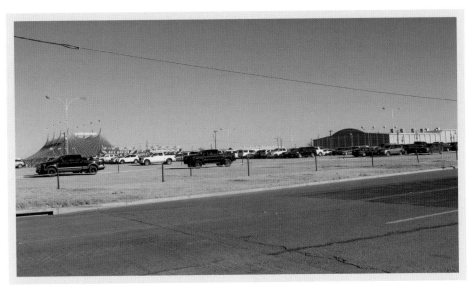

In the below photograph, many people are enjoying a rodeo that occurred at the Fair Park in 1923. The first fair was held in 1914. The annual South Plains Fair serves as a regional attraction and attracts visitors from across the area. Numerous nonprofits run booths during the fair to add to their coffers. The current image shows the growth of the fairgrounds complex and the big tops of the Garden Bros. Nuclear Circus. (Below, courtesy of the Southwest Collection, Texas Tech University.)

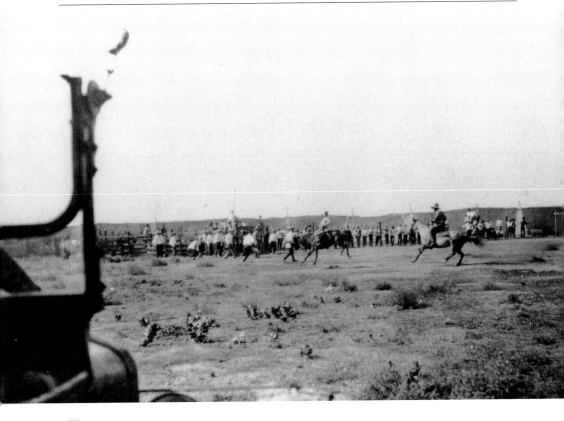

SHOWTIME IN THE HUB

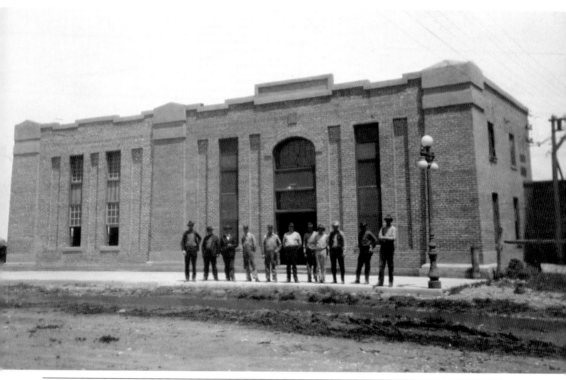

Pictured above around 1920 is a group of unidentified men in front of the City Light Plant at Fifth Street and Avenue J. This area of the city has been revitalized as the Arts District, and many of the buildings have been repurposed and rejuvenated. The Louise Hopkins Underwood Center for the Arts Ice House is used for many endeavors and is also the home of Raíces Compañía de Danza, which specializes in Mexican folklore dance. (Above, courtesy of the Southwest Collection, Texas Tech University.)

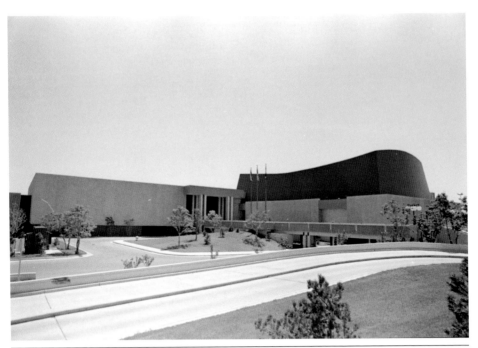

The Lubbock Memorial Civic Center, shown above in 1977, was built after the May 11, 1970, tornado and was dedicated to the memory of those who lost their lives due to the tornado. The Arts Festival, Cowboy Symposium, Viva Aztlan Festival, and Fiestas Del Llano are among the community events hosted at the civic center. Numerous organizations use the facility's theater, gallery spaces, and gathering areas for their various events. (Above, courtesy of University Archives, Texas Tech University.)

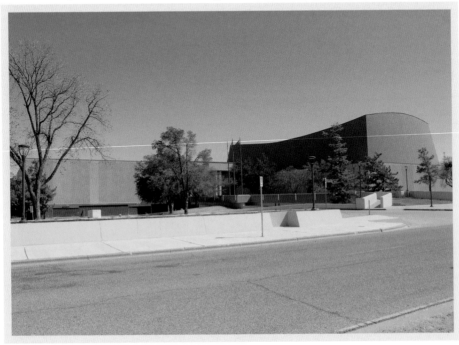

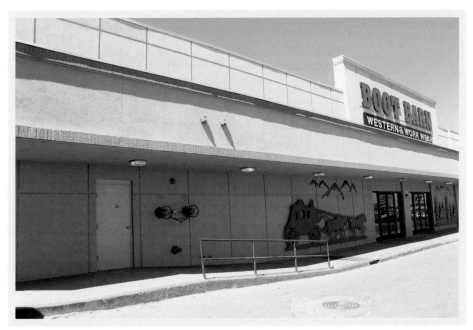

Lubbock's South Plains Mall opened its doors during the summer of 1972. The below image from 1974 shows a line of patrons waiting outside the South Plains Cinema to see *The Exorcist*. The mall was a harbinger of things to come and signaled the shift of business from the city core to the suburbs. The mall continues to expand and undergo renovations. The South Plains Cinema location is now a Boot Barn. (Below, courtesy of University Archives, Texas Tech University.)

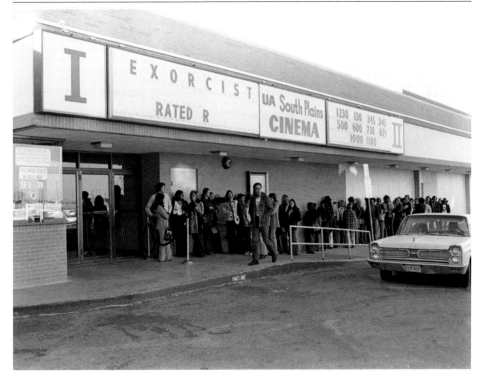

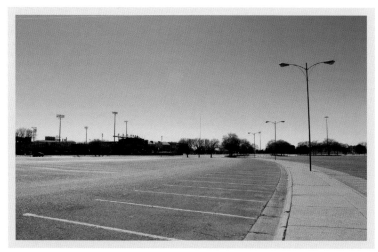

This undated image below shows the Lubbock Municipal Auditorium and Coliseum from the vantage point of a Texas Tech University commuter lot. The "Bubble," as it was affectionately called, boosted Texas Tech University's cause when it sought acceptance into the Southwest Athletic Conference. Concerts, rodeos, basketball, and hockey were a few of the events held in the coliseum. The Lubbock Municipal Auditorium hosted Ballet Lubbock, the Lubbock Symphony, and numerous touring shows. The buildings were demolished in 2019. (Below, courtesy of the Southwest Collection, Texas Tech University.)

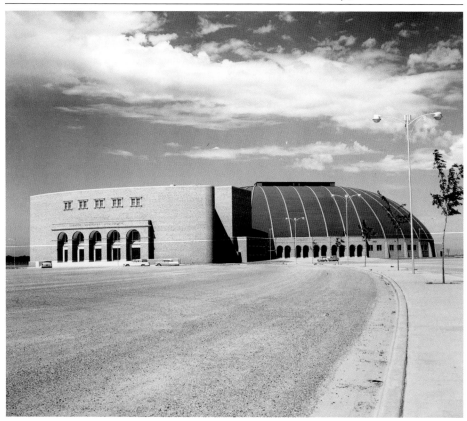

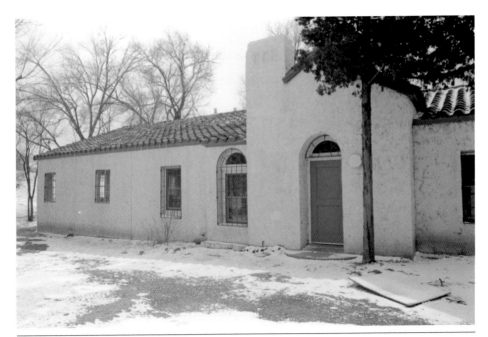

The above image of the Landwer-Manicapelli House in the Buddy Holly Recreation Area was taken in 1982. The structure was on course to be demolished when the Lubbock Heritage Society approached city council member Victor Hernandez about saving the building. Eventually, the Fiestas del Llano Inc. board of directors and the city council reached a consensus to save the building, which now serves as the Hispanic Culture Center, a project of Fiestas del Llano Inc. (Above, courtesy of University Archives, Texas Tech University.)

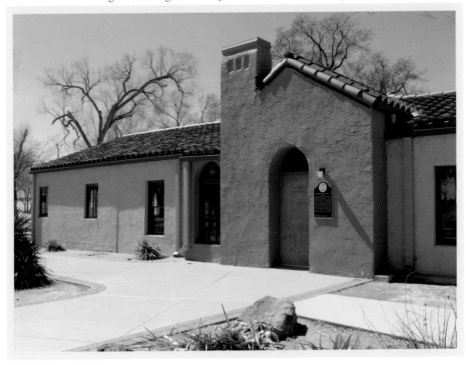

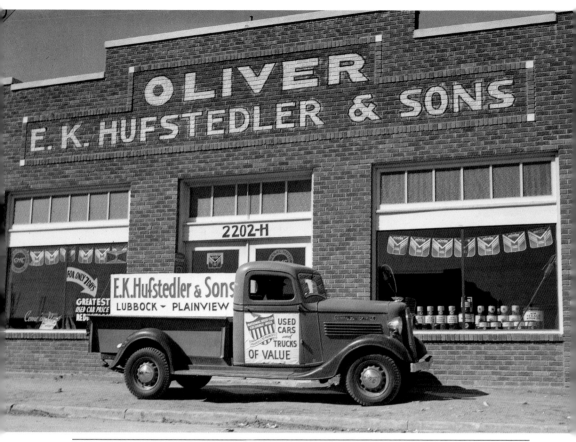

Located at 2202 Avenue H, Oliver E.K. Hufstedler & Sons is shown above in the 1930s. The business sold used cars and trucks. Avenue H was renamed Buddy Holly Avenue in 1996. Eden at the Beer Garden, a performance and event center, now occupies the structure at 2202 Buddy Holly Avenue. Located south of Nineteenth Street, this area is known as the Lower Depot. The area north of Nineteenth Street is known as the Depot. (Above, courtesy of the Southwest Collection, Texas Tech University.)

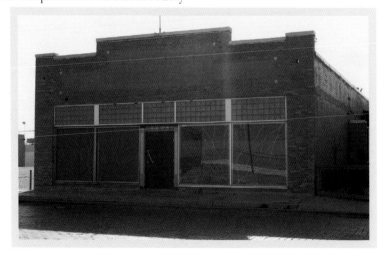

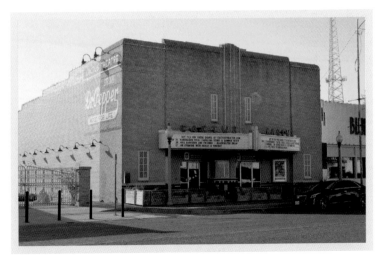

King of the Underworld, starring Kay Frances and Humphrey Bogart, was released in 1939 and was the feature at the Cactus Theater when the below photograph was taken. The theater, located at 1812 Buddy Holly Avenue, thrived through the late 1950s and then languished for years. Don Caldwell and other investors bought the theater and refurbished it. Reopened as a live venue in 1995, the theater has featured a myriad of talented performers, musicals, and special events. (Below, courtesy of the Southwest Collection, Texas Tech University.)

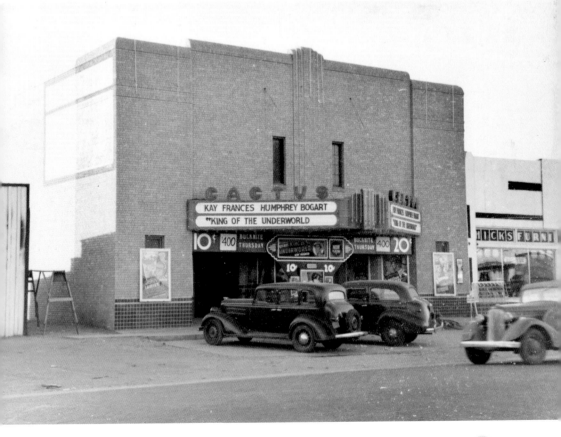

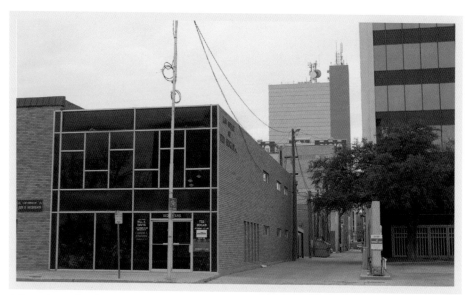

Below, the undated image of the Lyric Theater at 1114 Texas Avenue shows patrons reading the marquee, which advertises *Golden Boy*, starring Barbara Stanwyck and William Holden. The Lubbock Hotel is shown rising behind the other structures. The current image shows a law office occupying the theater space and the nearby bank's drive-through. Renamed the Pioneer Pocket Hotel in 2018, the partly obscured hotel building remains a feature of the downtown skyline. (Below, courtesy of the Southwest Collection, Texas Tech University.)

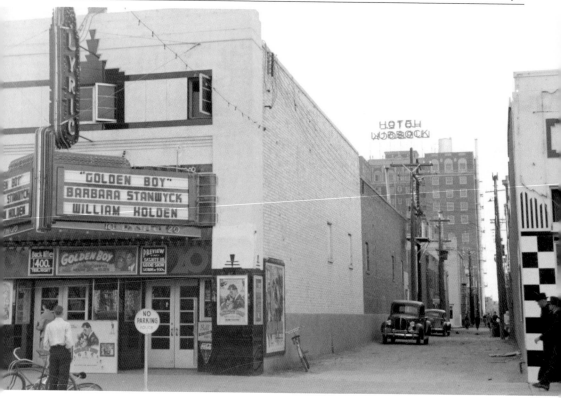

TAKE CARE!

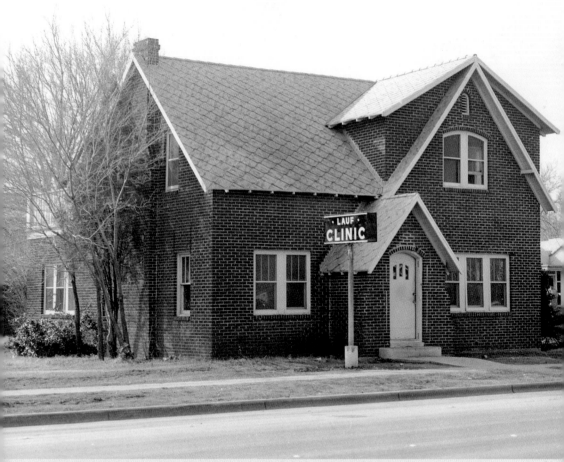

Located at 2349 Nineteenth Street, the Lauf Clinic was frequented by many Lubbock natives. It was one of the first clinics to offer its services to nonwhite communities. If not for the sign in front of the building, the clinic could have been mistaken for a grand home. (Courtesy of the Southwest Collection, Texas Tech University.)

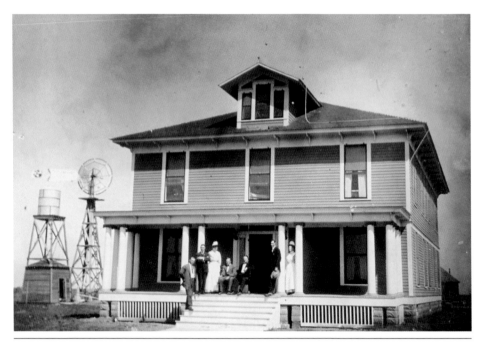

The undated image above shows Lubbock's first hospital, the Lubbock Sanitarium and Hospital. Located at what is now Main Street and Avenue O, it was founded in 1911. While the legacy of healthcare continues, the building is long gone. The Cotton Court and the Midnight Shift now rule the block—these are among the new ventures contributing to the revitalization of Lubbock's downtown. (Above, courtesy of the Southwest Collection, Texas Tech University.)

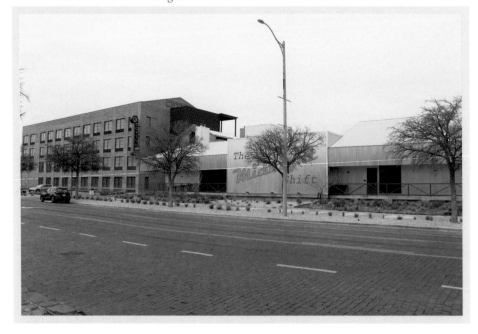

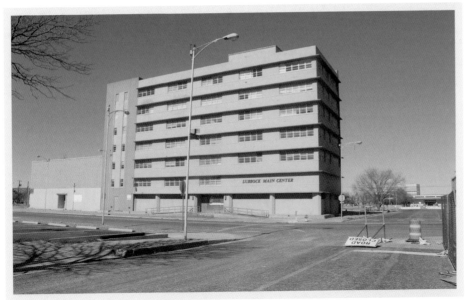

The West Texas Hospital is located at 1302 Main Street. After surviving the May 11, 1970, tornado, the building underwent major structural changes. One of the most evident was the addition of three stories. The renovation maintained the architectural lines of the original building. The hospital moved in the 1970s and eventually closed its doors. The building was listed for sale in 2020; as of 2022, when this book was published, it remained vacant and for sale. (Below, courtesy of the Southwest Collection, Texas Tech University.)

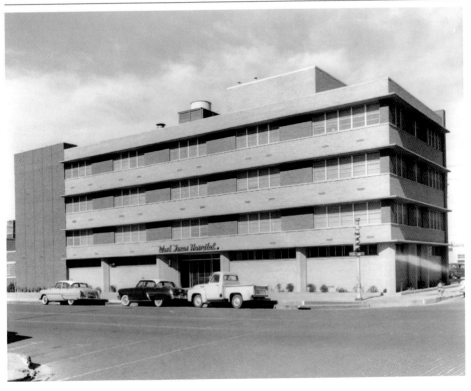

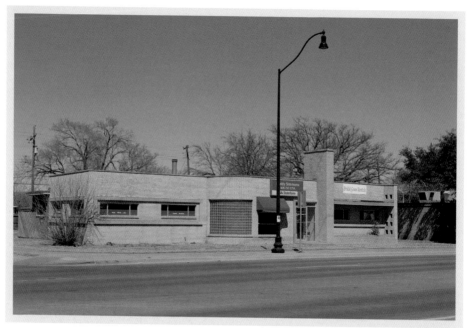

The below photograph of Day Chiropractic Clinic, located at 2124 Thirty-Fourth Street, was taken in 1951. The structure's classic architectural lines and curves remain mostly unchanged. The long rectangular window forms and the curved glass-block entrance still greet visitors today. It remains a microcosm of a time when form and function were paired into a pleasing visual aesthetic. The structure is now home to a bridal gown shop and State Farm Insurance agency. (Below, courtesy of the Southwest Collection, Texas Tech University.)

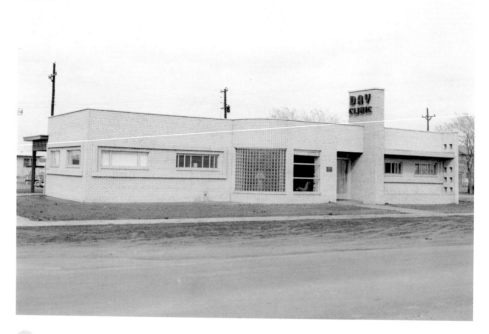

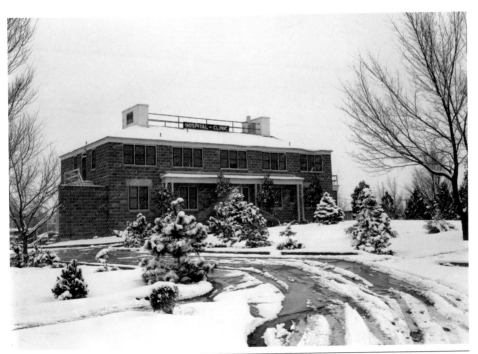

Shown above is a 1940s image of the Chatman Hospital, located at 2301 Cedar Avenue. It had a 16-bed capacity, two operating rooms, and other specialty rooms. This clinic was the only medical facility for African Americans in segregated Lubbock. The structure suffered a fire in 1987 and was restored to its original state in 1993. On June 16, 2022, a rededication ceremony was held to formally transfer ownership of the Chatman Clinic to the Community Health Center of Lubbock. (Above, courtesy of the Southwest Collection, Texas Tech University.)

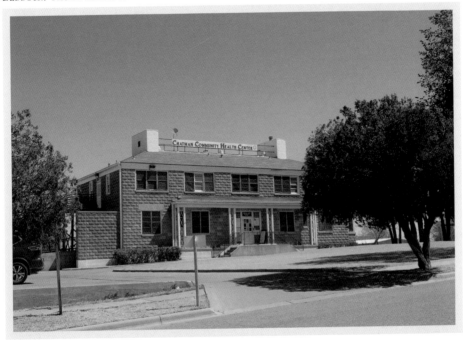

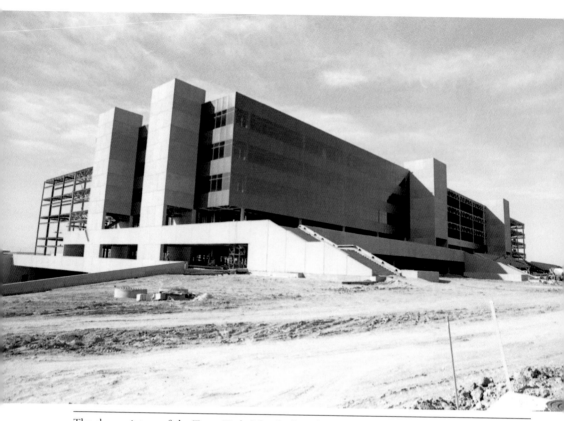

The above picture of the Texas Tech School of Medicine was taken in 1975. The school was created by the 61st Texas Legislature on May 29, 1969. The school has been an innovator, as reflected by the name change to Texas Tech University Health Services Center. As a member of the Texas Tech University System, it offers a variety of disciplines. The complex also includes the University Medical Center Health System. (Above, courtesy of University Archives, Texas Tech University.)

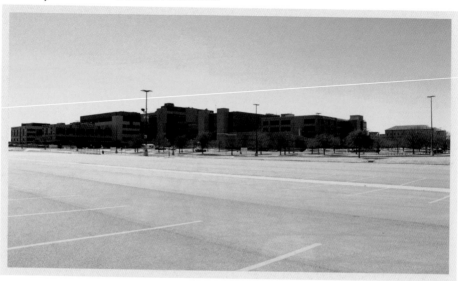

Some of the damage the Fields and Company building sustained during the May 11, 1970, tornado is shown in the below photograph. The store was in the path of the F5 tornado and suffered the wrath of the devastating storm.

The Community Health Center of Lubbock built new headquarters in 2015 on the site of the demolished Fields and Company building. (Below, courtesy of the Southwest Collection, Texas Tech University.)

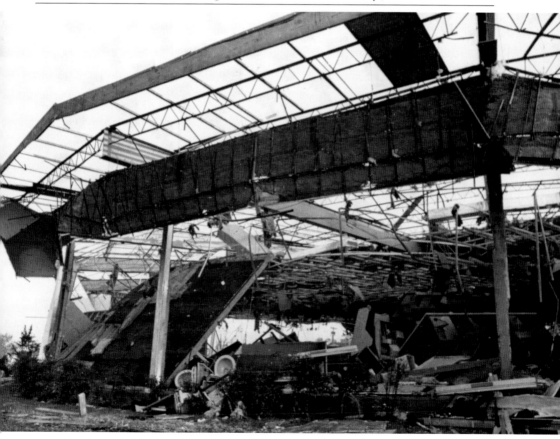

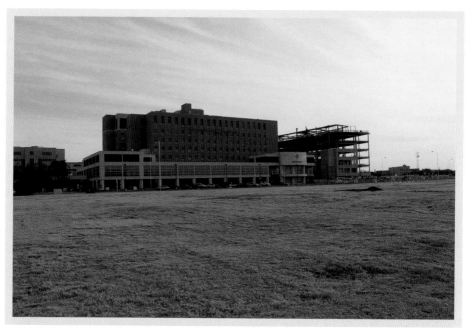

Taken from the Texas Tech University campus, the 1980 image below shows Methodist Hospital, located on the 3600 block of Nineteenth Street. Later renamed the Covenant Medical Center, the hospital encompasses several city blocks. The current image captures the expansions on the north side of the complex. The additions toward the south include a skywalk. The hospital is part of Covenant Health System, a vast enterprise with multiple locations. (Below, courtesy of the Southwest Collection, Texas Tech University.)

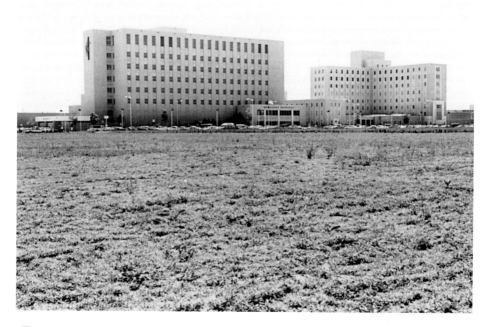

TAKE CARE!

EAT, DRINK, AND BE MERRY

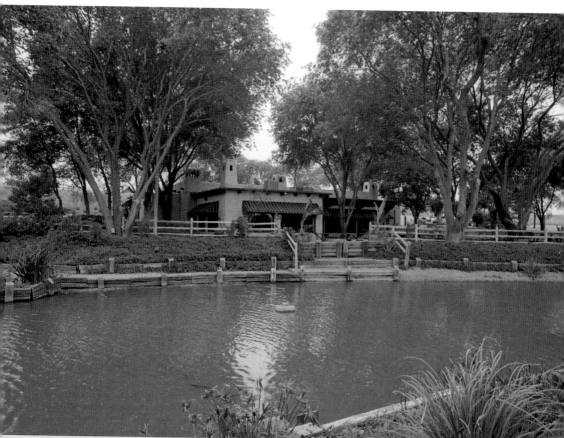

This undated image shows the Road House Restaurant at 701 Regis Street. The restaurant and its facilities attracted plenty of visitors to the far north of Lubbock's city boundary. Now Escondido Grill, it continues to entice guests with great food, a scenic waterfront view, and pheasants roaming the grounds. (Courtesy of University Archives, Texas Tech University.)

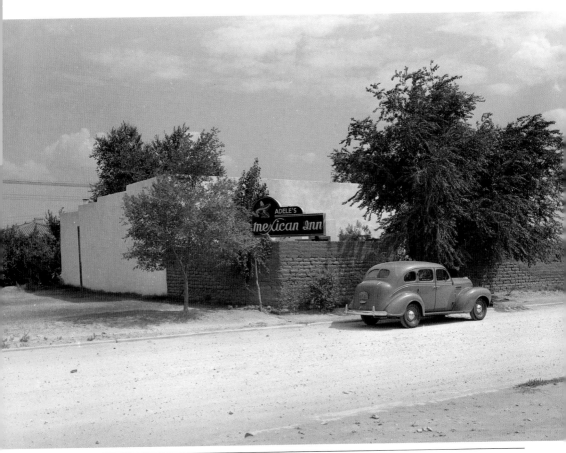

The above picture of Adele's Mexican Inn, located at 1905 Avenue R, was taken in the 1940s. Adele Wilson was the owner of the inn. At first glance, the inn looks small, but upon closer inspection, the edges of the building can be seen extending past the tree line. By the 1950s, a new Mexican Inn had opened on Avenue Q. The Parks Printing Company building now exists in the Avenue R location. (Above, courtesy of the Southwest Collection, Texas Tech University.)

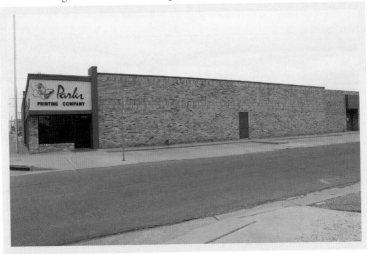

EAT, DRINK, AND BE MERRY

Ted Quan, a Chinese immigrant, opened the Ming Tree restaurant at 2008 Broadway Street. The original building is shown below in the 1950s. Quan left the downtown location and moved his restaurant in 1958. The building no longer exists, and the site is a parking lot for H.G. Thrash and Miguel's. H.G. Thrash is a men's clothing store, and Miguel's is a Mexican cocina and bar restaurant. (Below, courtesy of the Southwest Collection, Texas Tech University.)

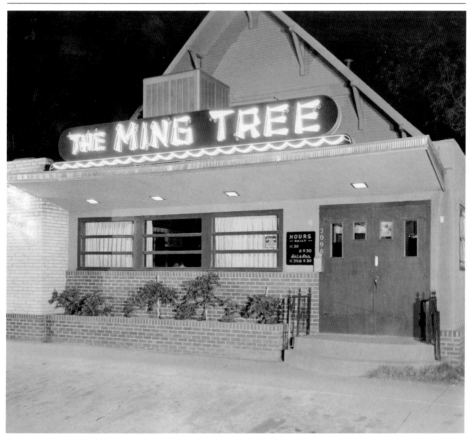

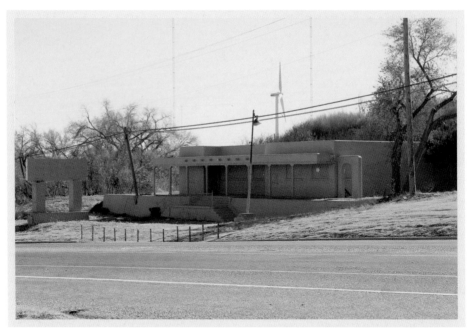

The Cliffhouse Restaurant, located at 510 East Broadway Street, is pictured below in 1953 during its prime. The restaurant offered guests a scenic view of Mackenzie Park. As the years passed, the building was abandoned and vandalized. In 2017, Guadalupe Economic Services Corporation entered into an agreement with the Cliffhouse Project to refurbish and reuse the structure. However, efforts to revitalize the building waned, and it is currently boarded up and unoccupied. (Below, courtesy of the Southwest Collection, Texas Tech University.)

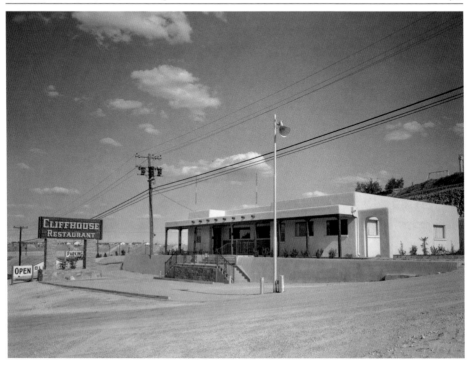

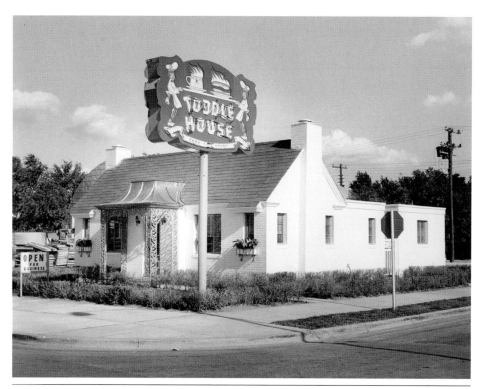

The Toddle House, located at 2245 Nineteenth Street, is shown above. Typical of the national chain's cozy cottage-style buildings, the exterior featured two chimneys and a manicured lawn. Over the years, an addition was put on the building. Unfortunately, the addition failed to retain the original building's cottage charm. City Donuts currently occupies the repurposed structure. (Above, courtesy of the Southwest Collection, Texas Tech University.)

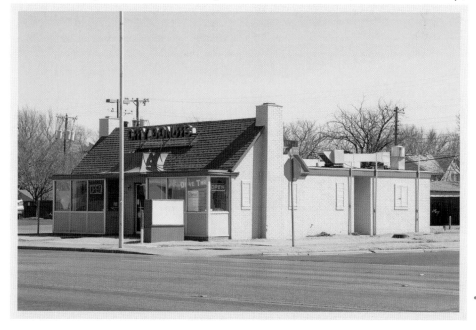

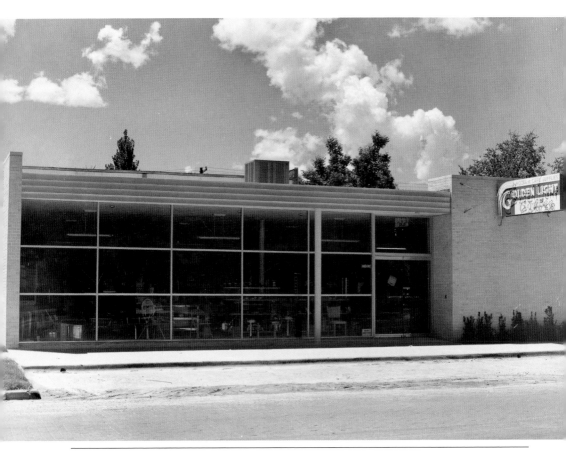

The Golden Light Coffee Company is pictured above in 1949. The company was located at 2107 Broadway Street and provided the necessary supplies for hotels and cafés. The building remains unchanged and is currently unoccupied. The adjoining building belongs to the Lubbock Arts Alliance, an organization dedicated to ensuring Lubbock has a strong and vibrant arts community. (Above, courtesy of the Southwest Collection, Texas Tech University.)

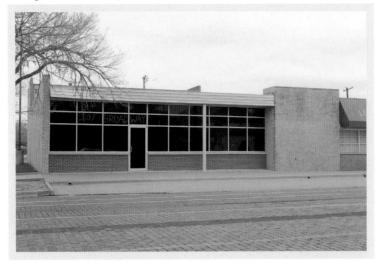

Eat, Drink, and Be Merry

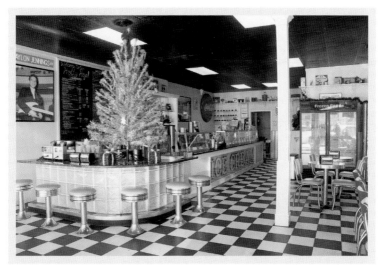

The below image of the interior of the Plains Ice Cream Company, located at 2230 Nineteenth Street, shows a typical 1950s ice cream shop. The menu consisted of ice cream, sandwiches, sundaes, and drinks. Holly Hop Ice Cream Shoppe, pictured above, is located at 3404 Thirty-Fourth Street. This unique ice cream parlor recreates the ambience and food of the 1950s. It offers traditional and new items, including delicious homemade ice cream. (Below, courtesy of the Southwest Collection, Texas Tech University.)

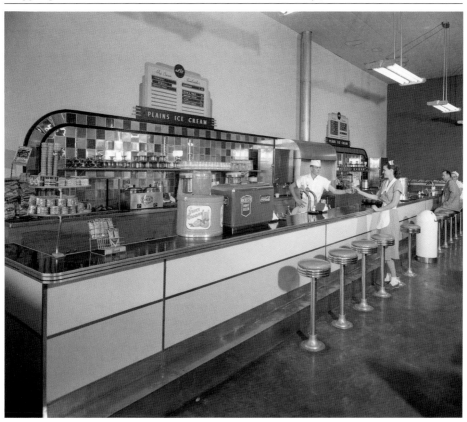

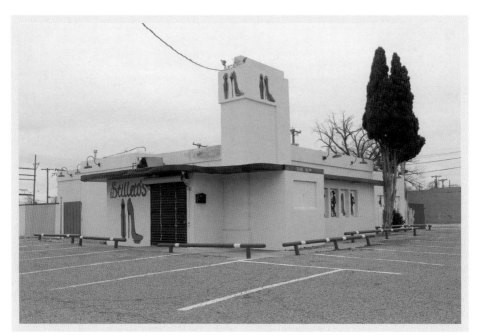

The 1954 image below shows Kattmann's Restaurant, located at 1801 Nineteenth Street. Over the years, the building has been home to an array of restaurants and bars. Crossroads and the Town Draw were popular in their heyday and would often fill to capacity. Stilettos Dance Hall occupies the building today and can be rented out for private or public events. (Below, courtesy of the Southwest Collection, Texas Tech University.)

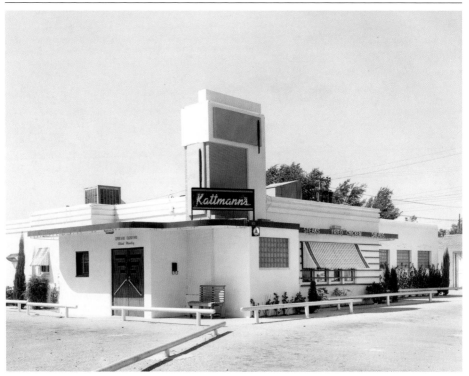

EAT, DRINK, AND BE MERRY

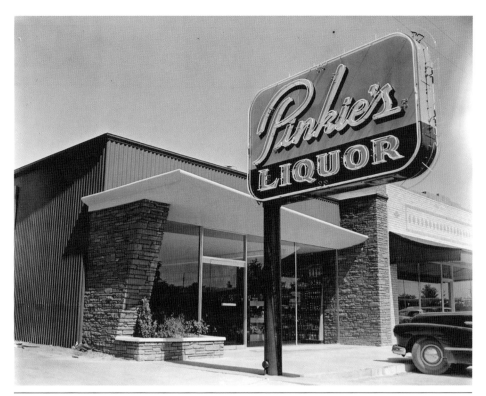

The 1950s image above showcases Pinkie's Liquor Store, an anchor of Lubbock's infamous strip. Pinkie's was known for great barbeque and gizzards. Starting in the 1930s, the strip held a monopoly on liquor sales. Once prohibition ended in 2009, Pinkie's moved into town. Today, the strip is no longer a little Las Vegas full of flashing neon lights. Pinkie's now has two liquor store locations and one location dedicated to serving barbeque. (Above, courtesy of the Southwest Collection, Texas Tech University.)

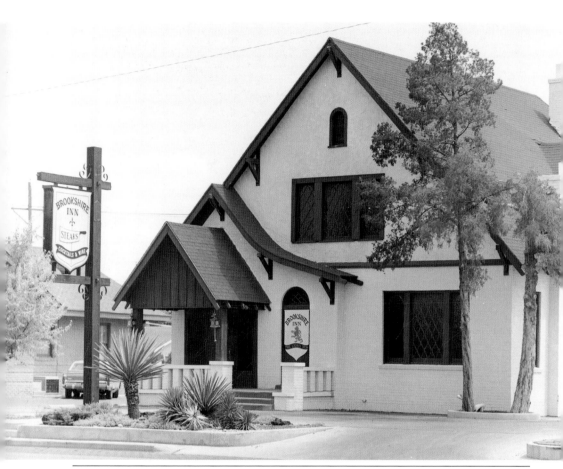

The Brookshire Inn is pictured above in 1973. Located at 2009 Broadway Street, the restaurant was once a grand home. Gardski's Loft took over for several years, running a very successful operation catering to the Texas Tech game-day crowds. Numerous organizations also found the spot to be an ideal location for monthly meetings. Today, Bier Haus operates at the location. (Above, courtesy of the Southwest Collection, Texas Tech University.)

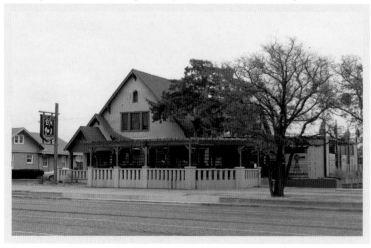

EAT, DRINK, AND BE MERRY

The 1948 image below shows the Coca-Cola Bottling Building constructed in the 1930s. Located at 1615 Texas Avenue, the structure was repurposed in 2008 as McPherson Cellars. The endeavor honors Dr. Clinton "Doc" McPherson, pioneer of the Texas wine industry. The acclaimed and recognized winery is located in the Depot Entertainment District. McPherson Cellars features a tasting room and an events center for hosting private or public events. (Below, courtesy of the Southwest Collection, Texas Tech University.)

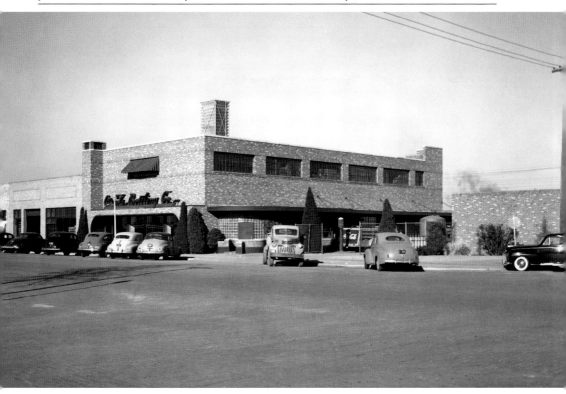

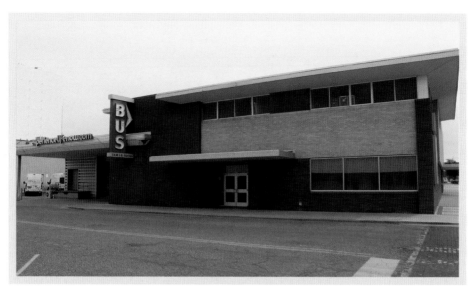

Fox's drive-in restaurant is shown below in 1945. Located at 1313 Thirteenth Street, the local drive-in offered an array of typical diner classics, including sandwiches, fried chicken, and thick malts. The building was later completely altered and then used by Texas, New Mexico & Oklahoma motor coach company, based in Lubbock. Experience Life Church now occupies the space, renting out the fittingly named Bus Event Center to raise funds for its ministry. (Below, courtesy of the Southwest Collection, Texas Tech University.)

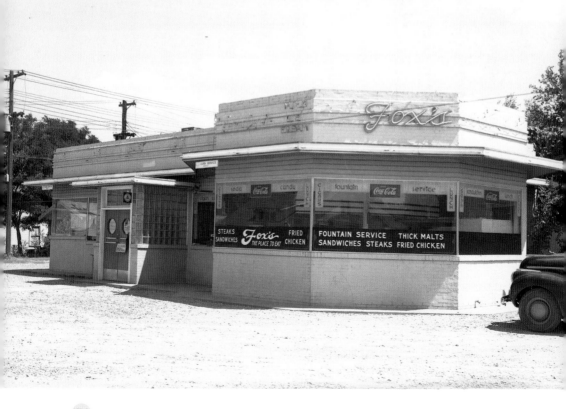

Eat, Drink, and Be Merry

LUBBOCK IS OPEN
FOR BUSINESS

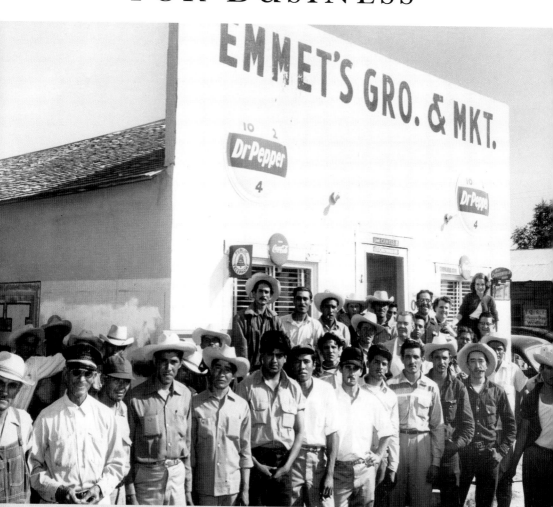

Mexican American citizens are pictured in front of Emmet's Grocery & Market, located at 1419 Avenue F, around 1954. Because of racial injustices, Mexican Americans had few options for where and when to shop. Many of them would fill the streets of downtown Lubbock during their weekend shopping sprees. (Courtesy of the Southwest Collection, Texas Tech University.)

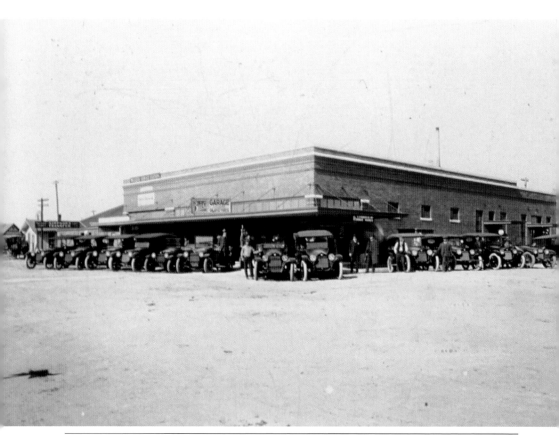

The undated image above features the Buick Garage at Avenue J and Main Street. From left to right, Oscar Tubbs, Rob Tubbs, and Bill Mckinely are shown in front of the garage. Currently, the building is home to the Michael H. Carper law office and a thrift shop. There is a tattoo shop a few doors down. (Above, courtesy of the Southwest Collection, Texas Tech University.)

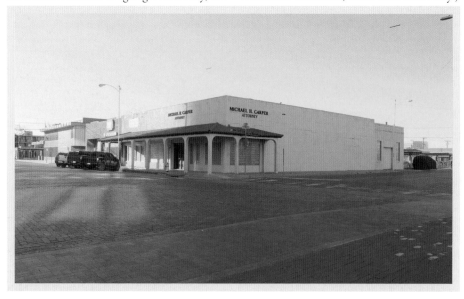

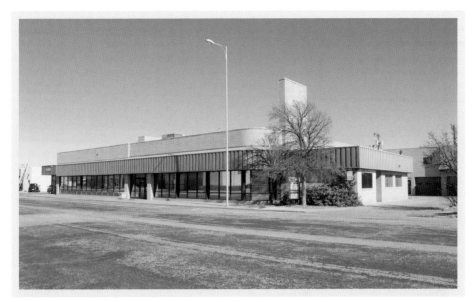

The photograph below is from 1954 and shows Scoggin-Dickey Buick Company. Owned by A.L. Scoggin and Jay Ray Dickey, this 1920 Texas Avenue location flourished, offering authorized Buick service and the latest models. Over time, Scoggin-Dickey Chevrolet-Buick has grown, and the company eventually built a new facility at Spur 327 and Frankford Avenue. As of July 2022, the structure maintains most of its original exterior facade. (Below, courtesy of the Southwest Collection, Texas Tech University.)

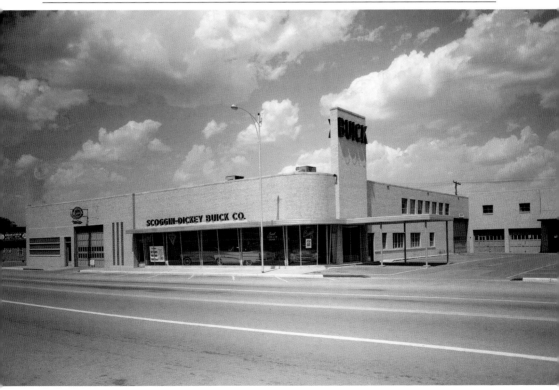

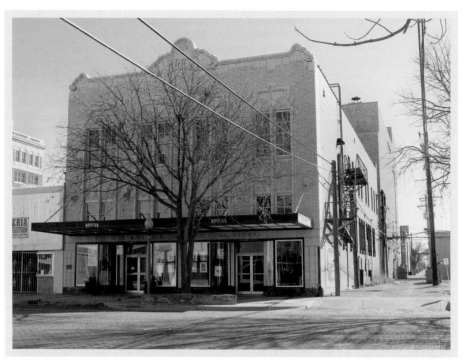

Located at 1109 Broadway Street, the Kress Building housed an S.H. Kress and Company store until 1975. Designed by Edward H. Sibbert and built in 1932, the Kress Building showcases Mission–Spanish Revival architecture. It was added to the National Register of Historic Places in 1992. Externally, the building remains unchanged. It is now home to the Burklee Hill bistro and tasting room. (Below, courtesy of the Southwest Collection, Texas Tech University.)

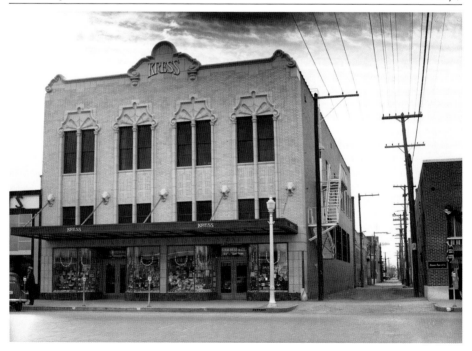

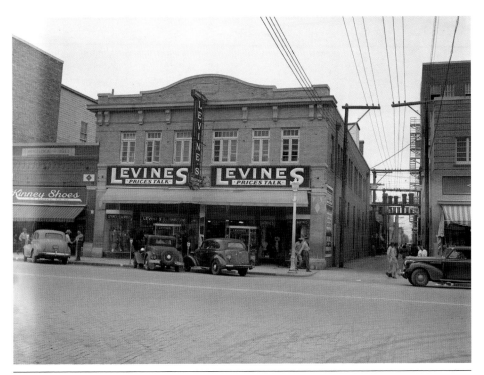

The 1946 photograph above shows Levine's department store in downtown Lubbock at 1009 Broadway Street. Next to Levine's was a Kinney Shoes store. Today, the Kinney building is home to various attorneys. After Levine's opened a new store next to its original location, the old building was demolished and became a parking lot. (Above, courtesy of the Southwest Collection, Texas Tech University.)

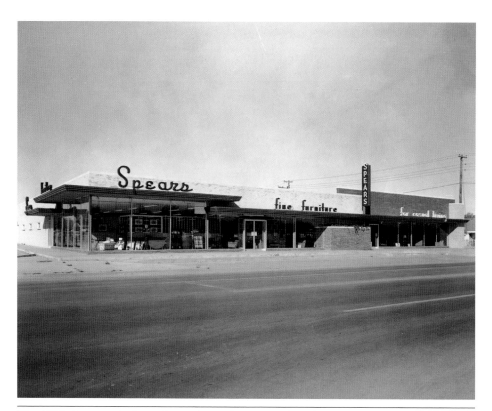

The 1954 photograph above shows the mid-century-inspired Spear's Furniture located on the northwest corner of Twenty-Eighth Street and Avenue Q. The company's tagline—"fine furniture for casual living"—welcomed guests to stop by and see what it had to offer. The facade of the building, which is now home to Fresenius Medical Care, is now more enclosed and less welcoming. (Above, courtesy of the Southwest Collection, Texas Tech University.)

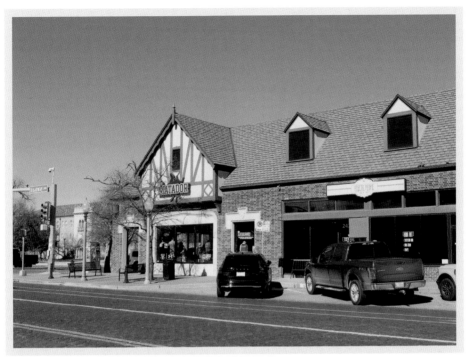

On the northeast corner of the intersection of Broadway Street and College Avenue, Halsey's Drug Store anchored a host of businesses. In the background is Sneed Hall on Texas Tech University's campus. Today, these businesses have been replaced with restaurants, stores, and bars, with the bulk of the business coming from Texas Tech students. Sneed Hall still provides living quarters for students. (Below, courtesy of the Southwest Collection, Texas Tech University.)

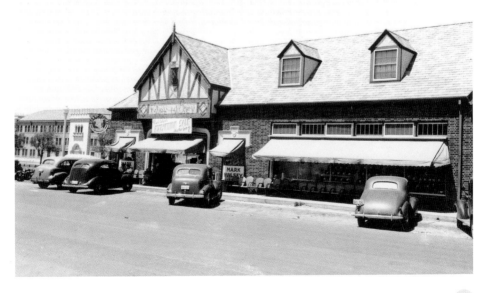

Pictured below in 1954, this Radio Lab, located at 1501–1503 Avenue Q, was owned by H.L. Griffith. Hoffman, Motorola, and Philco were among the brands carried by the business. City Tailors was located next to the electronics and appliance store. Today, a Prosperity Bank processing facility is at this location. (Below, courtesy of the Southwest Collection, Texas Tech University.)

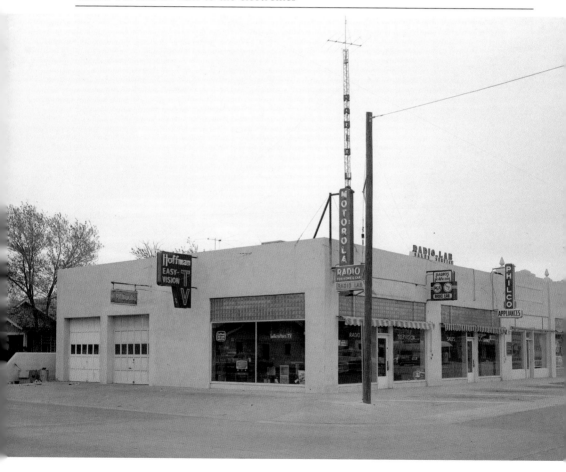

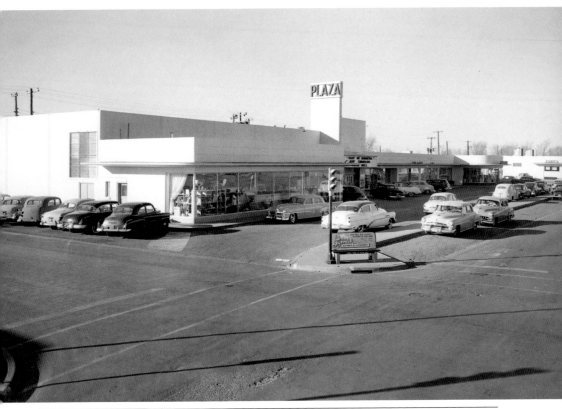

Plaza Shopping Center, located at Twenty-Sixth Street and Boston Avenue, serves the needs of residents of the Green Acres subdivision. Today, J&B Coffee Company anchors the shopping center, which includes Lillie's Bridal and Capital Pizza. Although small shopping centers with locally owned shops and restaurants remain tucked in neighborhoods, current development trends in Lubbock have pushed the major retail shopping centers to the outer edges of town. (Above, courtesy of the Southwest Collection, Texas Tech University.)

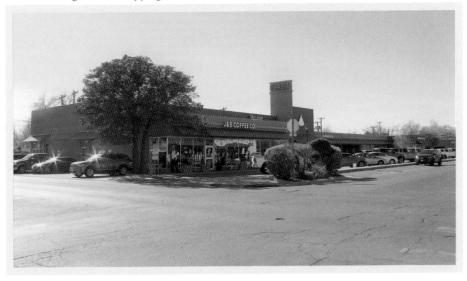

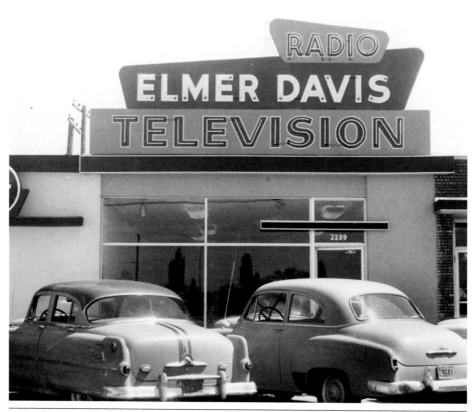

Elmer Davis Television was located at 2239 Thirty-Fourth Street. It was representative of the small storefronts that were prevalent during the 1950s. Because of the growing population and higher demand for electronic necessities, these small electronics stores were displaced by national chains. Other businesses and organizations now occupy the area, including Ministerios Alto Refugio. (Above, courtesy of the Southwest Collection, Texas Tech University.)

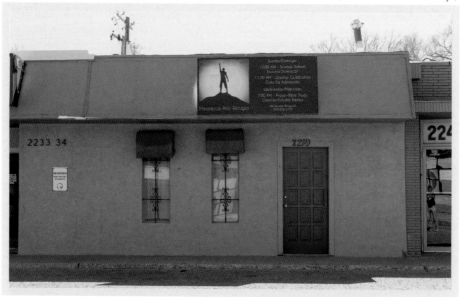

Maxey Lumber Company was located at 124 North College Avenue and owned by prominent businessman Homer G. Maxey. Now occupying the area are Amigos, Family Dollar, Dollar Tree, Rent-A-Center, A-MAX Auto Insurance, and McDonald's. Amigos is part of the United Family of stores and was created with the intent to serve the needs of the primarily Mexican American Arnett Benson neighborhood and anyone else seeking traditional Mexican flavors. (Below, courtesy of the Southwest Collection, Texas Tech University.)

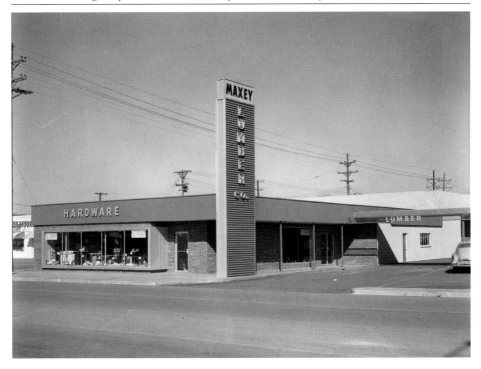

Modern Manor Shopping Center, located at Forty-Second Street and Boston Avenue, is pictured below in 1961. Businesses in the center included United Supermarkets, N.T. House, Wirz Drug, Family Cleaners, and the Modern Manor Beauty Shop. The above image shows the center with development in the foreground. In the center today are Plaza Cleaners, Sew Crazy sewing shop, and an AA group meeting place. (Below, courtesy of the Southwest Collection, Texas Tech University.)

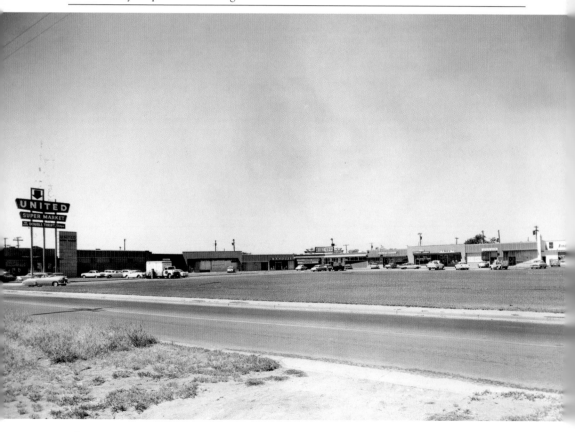

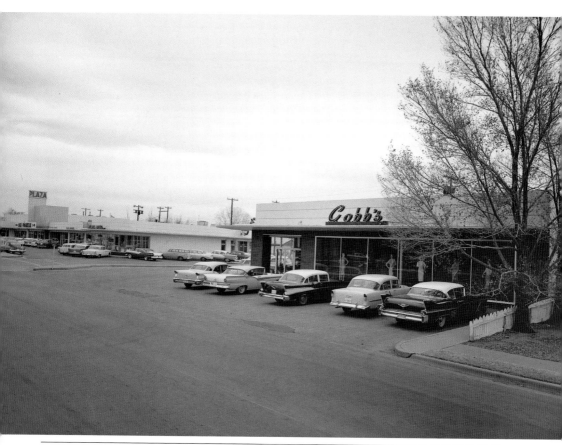

Cobb's department store was located just west of the Plaza Shopping Center. It offered convenient and centralized shopping for the residents of the Green Acres neighborhood. The building at 2801 Twenty-Sixth Street has been well cared for and now houses Studio West, the brainchild of Melissa Grimes. For more than 25 years, Studio West has specialized in interior design, and the company offers a full range of services. (Above, courtesy of the Southwest Collection, Texas Tech University.)

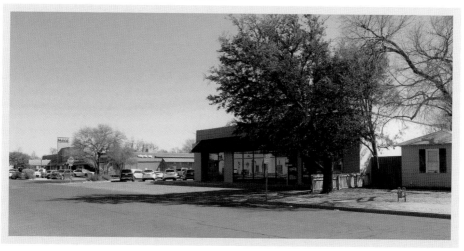

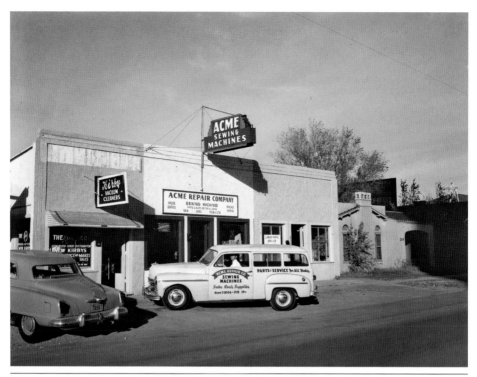

Owned by Elmer D. Harris, the Acme Sewing Machine Repair Company was located at 2118 Nineteenth Street. It sold and leased new, used, and rebuilt products. The customer-service vehicle shows the company's attention and dedication to serving loyal customers. The adjoining business is an authorized Kirby vacuum cleaner distributor. Acme Marking Products and the Lubbock Label Company now reside at the location. (Above, courtesy of the Southwest Collection, Texas Tech University.)

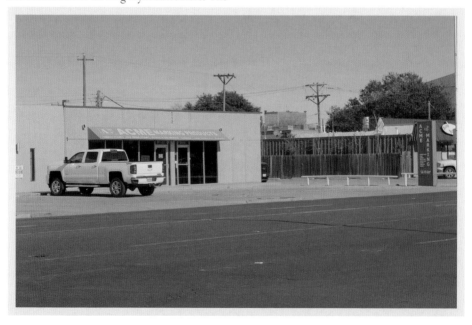

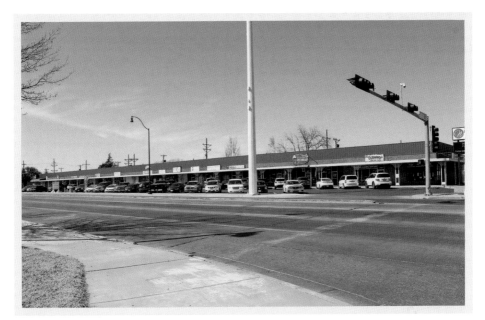

Taken in 1955, the below photograph shows the Piggly Wiggly grocery store in the Indiana Gardens shopping center on the northwest corner of Indiana Avenue and Thirty-Fourth Street. To the left of the Piggly Wiggly is the Twin Oaks Pharmacy. Although Piggly Wiggly no longer exists, Twin Oaks Pharmacy continues its operations. New tenants of the center include the Holly Hop Ice Cream Shoppe, Sugarista Cookies, and Rise Nutrition. (Below, courtesy of the Southwest Collection, Texas Tech University.)

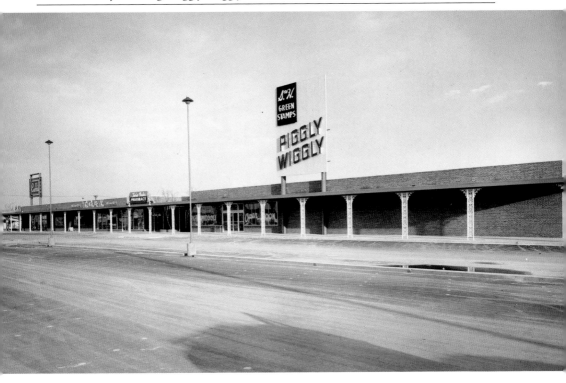

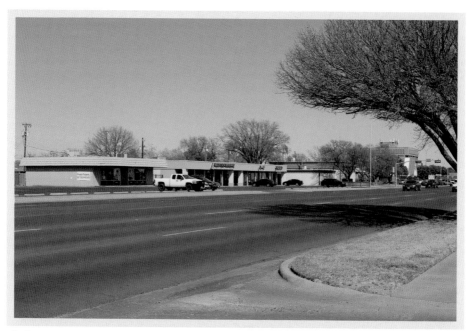

The below image shows businesses between Utica and Wayne Avenues on the 4800 block of Fiftieth Street in 1961. Handy Hut convenience store and Stride Rite Bootery are among the stores in the photograph. Currently, Mountain Hideaway, Jenny's Alterations, and Palacio Hair Designs are among the shops in the area. Tucked among the shops and trees are a Lubbock fire station and a Whataburger. (Below, courtesy of the Southwest Collection, Texas Tech University.)

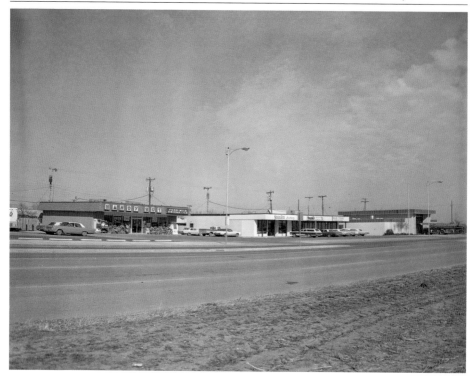

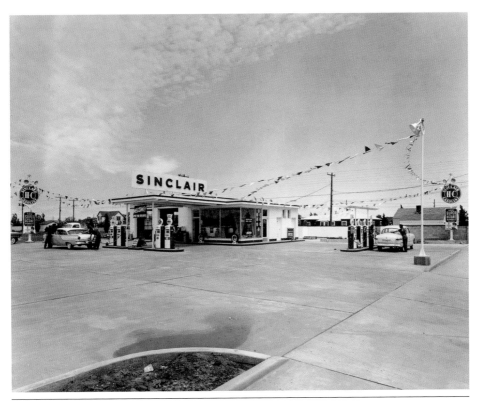

The Sinclair service station at Thirty-Fourth Street and Boston Avenue is pictured above in 1957. Sinclair operated numerous full-service stations in the Lubbock area. This location featured several gas pumps and two mechanic bays. Today, a Texas Car Title and Payday Loan company is headquartered in the refurbished building. (Above, courtesy of the Southwest Collection, Texas Tech University.)

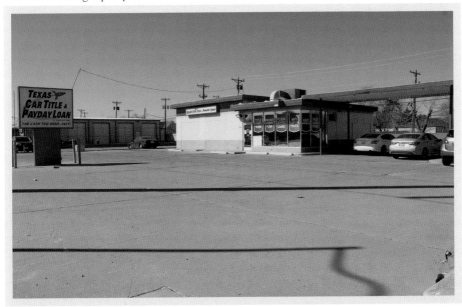

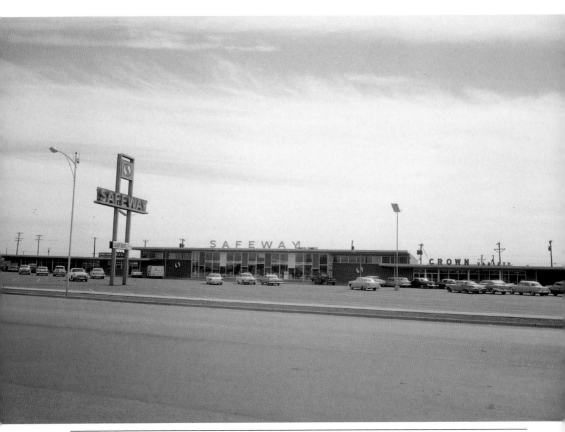

Featured in the 1960 image above is a Safeway grocery store at the southeast corner of Quaker Avenue and Thirty-Fourth Street. This area has seen some new developments and repurposing of buildings. While the Safeway is gone, several new businesses have moved into the center. Exodus Prison Ministry, Patty's Heart Quilt Shop, and Highland Baptist Student Ministry are a few of the tenants that now reside in the shopping center. (Above, courtesy of the Southwest Collection, Texas Tech University.)

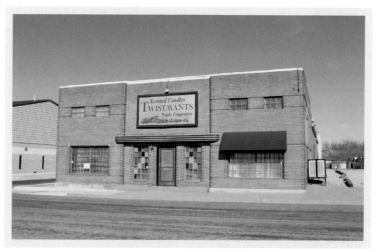

The below picture is from 1947 and features the Royal Crown Bottling Company building at 2901 Interstate 27. Opened in 1939, the company entered fierce competition with Coke and Pepsi until it closed its doors and went up for sale in 1970. The building was then home to a tire store and, later, the Ebonite Lounge. Now, the name Twistavants Scented Candles adorns the front facade, although that company is no longer in business. (Below, courtesy of the Southwest Collection, Texas Tech University.)

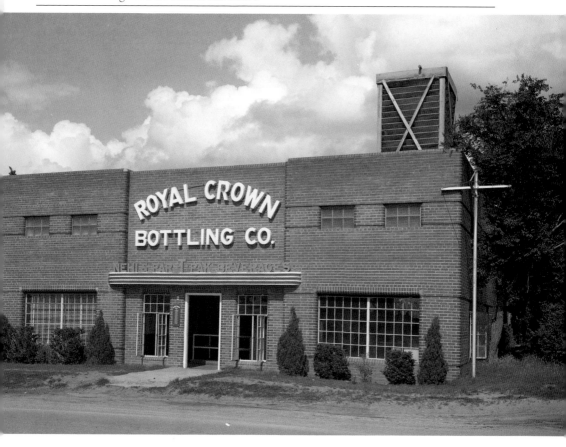

DISCOVER THOUSANDS OF LOCAL HISTORY BOOKS FEATURING MILLIONS OF VINTAGE IMAGES

Arcadia Publishing, the leading local history publisher in the United States, is committed to making history accessible and meaningful through publishing books that celebrate and preserve the heritage of America's people and places.

Find more books like this at
www.arcadiapublishing.com

Search for your hometown history, your old stomping grounds, and even your favorite sports team.